POETRY AND ANARCHISM

POETRY
AND ANARCHISM

by

HERBERT E. READ

Essay Index Reprint Series

BOOKS FOR LIBRARIES PRESS
FREEPORT, NEW YORK

First Published 1938
Reprinted 1972

Library of Congress Cataloging in Publication Data

Read, Sir Herbert Edward, 1893-1968.
 Poetry and anarchism.

 (Essay index reprint series)
 1. Anarchism and anarchists. 2. Poetry.
I. Title.
PN1081.R4 1972 824'.9'12 72-290
ISBN 0-8369-2819-9

PRINTED IN THE UNITED STATES OF AMERICA
BY
NEW WORLD BOOK MANUFACTURING CO., INC.
HALLANDALE, FLORIDA 33009

CONTENTS

9

The first philosophers, the original observers of life and nature, were the best; and I think only the Indians and the Greek naturalists, together with Spinoza, have been right on the chief issue, the relation of man and his spirit to the universe.

—SANTAYANA

By governing the people with love it is possible to remain unknown.

—LAOTSE

I tell you I had rather be a swineherd upon the flats of Amager and be understood of the swine, than be a poet and be misunderstood of men.

—KIERKEGAARD

I

NO PROGRAMME

To declare for a doctrine so remote as anarchism at this stage of history will be regarded by some critics as a sign of intellectual bankruptcy; by others as a sort of treason, a desertion of the democratic front at the most acute moment of its crisis; by still others as merely poetic nonsense. For myself it is not only a return to Proudhon, Tolstoy, and Kropotkin, who were the predilections of my youth, but a mature realization of their essential rightness, and a realization, moreover, of the necessity, or the probity, of an intellectual confining himself to essentials.

I am thus open to a charge of having wavered in my allegiance to the truth. In extenuation I can only plead that if from time to time I have temporized with other measures of political action—and I have never been an active politician, merely a sympathizing intellectual—it is because I have believed that such measures were part way to the

final goal, and the only immediately practical measures. From 1917 onwards and for as long as I could preserve the illusion, communism as established in Russia seemed to promise the social liberty of my ideals. So long as Lenin and Stalin promised a definitive 'withering away of the State' I was prepared to stifle my doubts and prolong my faith. But when five, ten, fifteen, and then twenty years passed, with the liberty of the individual receding at every stage, a break became inevitable. It was only delayed so long because no other country in the world offered a fairer prospect of social justice. It comes now because it is possible to transfer our hopes to Spain, where anarchism, so long oppressed and obscured, has at last emerged as a predominant force in constructive socialism. At the time I write the outcome of the struggle is still uncertain, but it is impossible to believe that the conscience of a modern people, once roused to a sense of its human rights, will ever again submit to a medieval tyranny. It is impossible to believe that with the examples of Russia and Germany before them, they will pass from a medieval to a modern tyranny. Let us rather believe that there are possibilities in the present situation which justify a renewal of our faith in human humility and individual grace. The will to power, which has for so long warped the social structure of Europe, and which has even possessed the minds of socialists, is renounced by a party that can claim to represent the vital forces of a nation.

14

For that reason I do not see why intellectuals like myself, who are not politicians pledged to an immediate policy, should not openly declare ourselves for the only political doctrine which is consistent with our love of justice and our need for freedom.

I speak of doctrine, but there is nothing I so instinctively avoid as a static system of ideas. I realize that form, pattern, and order are essential aspects of existence; but in themselves they are the attributes of death. To make life, to insure progress, to create interest and vividness, it is necessary to break form, to distort pattern, to change the nature of our civilization. In order to create it is necessary to destroy; and the agent of destruction in society is the poet. I believe that the poet is necessarily an anarchist, and that he must oppose all organized conceptions of the State, not only those which we inherit from the past, but equally those which are imposed on people in the name of the future. In this sense I make no distinction between fascism and marxism.

This tract is a personal confession of faith. It is not a programme, nor a party pronunciamento. I have no deliberate design on mankind. I have arrived at a personal equation: *Yo sé quién soy*— my ideas relate to myself. They are conditioned by my origin, my environment and my economic condition. My happiness consists in the fact that I have found the equation between the reality of my being and the direction of my thoughts.

15

In spite of my intellectual pretensions, I am by birth and tradition a peasant. I remain essentially a peasant. I despise the whole industrial epoch— not only the plutocracy which it has raised to power, but also the industrial proletariat which it has drained from the land and proliferated in hovels of indifferent brick. The only class in the community for which I feel any real sympathy is the agricultural class, including the genuine remnants of a landed aristocracy. This perhaps explains my early attraction to Bakunin, Kropotkin, and Tolstoy, who were also of the land, aristocrats and peasants. A man cultivating the earth—that is the elementary economic fact; and as a poet I am only concerned with elementary facts.

Deep down, my attitude is a protest against the fate which has made me a poet in an industrial age. For it is almost impossible to be a poet in an industrial age. In our own language, there have only been two genuine major poets since the industrial age established itself—Whitman and Lawrence. And they are great in their protestations—rarely in their positive expressions of joy. Whitman, it is true, was only half caught in the trap; he was born in a raw undeveloped country, which explains why he was so much more positive than Lawrence.

Nevertheless I realize that industrialism must be endured; the poet must have bowels to digest its iron aliment. I am no yearning medievalist, and have always denounced the sentimental reaction of

16

Morris and his disciples. I have embraced industrialism, tried to give it its true aesthetic principles, all because I want to be through with it, want to get to the other side of it, into a world of electric power and mechanical plenty when man can once more return to the land, not as a peasant but as a lord. The ether will deliver us the power which the old landlords extracted from serfs: there will be no need to enslave a single human soul. But we shall be in contact with the land; we shall have soil and not cement under our feet; we shall live from the produce of our fields and not from the canned pulp of factories.

I am not concerned with the practicability of a programme. I am only concerned to establish truth, and to resist all forms of discipline and coercion. I shall endeavour to live as an individual, to develop my individuality; and if necessary I shall be isolated in a prison rather than submit to the indignities of war and collectivism. It is the only protest an individual can make against the mass stupidity of the modern world. He can do it—if he can afford it—from the safe distance of a New Mexican Thebaid; but if he is poor he must cut a wry romantic figure on the ash-heaps of his own outraged country.

In the parochial atmosphere of England, to profess a belief in anarchism is to commit political suicide. But there are more ways than one of committing suicide, of escaping from the unendurable

17 B

injustice of life. One way is the mortal and effective way of a poet like Mayakovsky. I shall consider it in the next chapter. Another way is the way of the Thebaid—the way taken by the Christian intellectuals at a similar crisis in the world's history and the way taken in our own age by an artist like Gauguin. Gauguin is perhaps not a very important painter, but he is a pioneer in this particular mode of escape. He was the type of artist who, realizing the necessity of imagination and appreciating as keenly as anyone its qualities, set out consciously to seek it. He sought above all to create the material conditions in which it would function. He gave up his bourgeois occupation and his bourgeois marriage; he tried to avoid the most elementary economic and practical activities. 'My mind is made up: I want soon to go to Tahiti, a little island in Oceania, where material life has no need of money. A terrible epoch is being prepared in Europe for the coming generation: the reign of Gold. Everything is rotten, both men and the arts. Here one is incessantly distracted. There, at least, the Tahitian, under a summer sky and living on a wonderfully fertile soil, needs only to put out his hand to find food. Consequently he never works. Life, to the Tahitian, consists of singing and making love, so that once my material life is well organized, I shall be able to give myself up entirely to painting, free from artistic jealousy, and without any necessity for shady dealing.' Gauguin went to

18

Tahiti, but he was bitterly disappointed. He found that even in the South Seas you cannot escape 'the reign of Gold'. You merely find yourself at its outposts, and have to fight its most degraded exponents single-handed. You can, in short, only escape from civilization by entirely renouncing civilization —by giving up the struggle for beauty and fame and wealth—all bourgeois values to which Gauguin still pathetically clung. It was his friend, the poet Arthur Rimbaud, who accepted the only immediate alternative: complete renunciation, not merely of civilization, but of all attempts to create a world of the imagination.

Civilization has gone from bad to worse since Gauguin's time, and there are many young artists to-day whose only desire is to escape to some fertile soil under a summer sky, where they may devote themselves entirely to their art free from the distractions of an insane world. But there is no escape. Apart from the practical difficulty of finding a secure refuge in this world, the truth is that modern man can never escape from himself. He carries his warped psychology about with him no less inevitably than his bodily diseases. But the worst disease is the one he creates out of his own isolation: uncriticized phantasies, personal symbols, private fetishes. For whilst it is true that the source of all art is irrational and automatic—that you cannot create a work of art by taking thought—it is equally true that the artist only acquires his significance by

19

being a member of a society. The work of art, by processes which we have so far failed to understand, is a product of the relationship which exists between an individual and a society, and no great art is possible unless you have as corresponding and contemporary activities the spontaneous freedom of the individual and the passive coherence of a society. To escape from society (if that were possible) is to escape from the only soil fertile enough to nourish art.

The escape of Gauguin and the escape of Mayakovsky are thus only alternative methods of committing suicide. There only remains the path I have chosen: to reduce beliefs to fundamentals, to shed everything temporal and opportunist, and then to stay where you are and suffer if you must.

II

POETS AND POLITICIANS

On the 14th April, 1930, Vladimir Mayakovsky, then acknowledged as the greatest poet of modern Russia, committed suicide. He is not the only modern Russian poet who has taken his own life: Yessenin and Bagritsky did the same, and they were not inconsiderable poets. But Mayakosvky, by all accounts, was exceptional—the inspiration of the revolutionary movement in Russian literature, a man of great intelligence and of inspired utterance. The circumstances leading to his death are obscure, but he left behind him a piece of paper on which he had written this poem:

> *As they say*
> *'the incident is closed'.*
> *Love boat*
> *smashed against mores.*
> *I'm quits with life.*
> *No need itemizing*
> *mutual griefs*
> *woes*
> *offences.*
> *Good luck and good-bye.*[1]

[1]Trans. by Max Eastman, *Artists in Uniform*. (Allen & Unwin, 1934.)

There is no need to itemize. There is no need to detail the circumstances leading to this poet's death. Obviously there was a love affair, but to our surprise there were also the *mores*—the social conventions against which this love-boat smashed. Mayakovsky was in a very special sense the poet of the Revolution: he celebrated its triumph and its progressive achievements in verse which had all the urgency and vitality of the event. But he was to perish by his own hand like any miserable in-grown subjectivist of bourgeois capitalism. The Revolution had evidently not created an atmosphere of intellectual confidence and moral freedom.

We can understand and draw courage and resolution from the death of Garcia Lorca, who was shot by fascists at Granada in 1936. On the whole, an undisguised hatred of poets is preferable to the callous indifference of our own rulers. In England poets are not regarded as *dangerous* individuals— merely as a type that can be ignored. Give them a job in an office, and if they won't work let them starve. . . .

In England or in Russia, in America or in Germany, it all comes to the same: in one way or another poetry is stifled. That is the world-wide fate of poetry. It is the fate of poetry in our civilization, and Mayakovsky's death merely proves that in this respect the new civilization of Russia is only the same civilization in disguise. Nor are poets the only artists to suffer—composers, painters, and

22

sculptors, are in the same love-boat, smashed against the *mores* of the totalitarian state. War and revolution have achieved nothing for culture because they have achieved nothing for freedom. But that is too vague and grandiloquent a way of expressing the simple truth: what I really mean is that the doctrinaire civilizations which are forced on the world—capitalist, fascist and marxist—by their very structure and principles exclude the values in which and for which the poet lives.

Capitalism does not challenge poetry in principle—it merely treats it with ignorance, indifference and unconscious cruelty. But in Russia, Italy, Germany, and fascist Spain, there is neither ignorance nor indifference, and the cruelty is a deliberate persecution leading to execution or suicide. Both fascism and marxism[1] are fully aware of the power of the poet, and because the poet is powerful, they wish to use him for their own political purposes. The conception of the totalitarian state involves the subordination of all its elements to a central control, and not least among such elements are the aesthetic values of poetry and of the arts in general.

This attitude towards art goes back to Hegel, in whom both marxism and fascism have their source. In his anxiety to establish the hegemony of the

[1] I always use 'marxism' to designate the centralized totalitarian conception of communism as distinct from the devolutionary types which I call 'anarchism'.

23

spirit or the Idea, Hegel found it necessary to relegate art, as a product of sensation, to a past historical stage in human development. Art he regarded as a primitive mode of thought or representation which had been gradually superseded by the intellect or reason; and consequently, in our present stage of development, we ought to put art away like a discarded toy.

Hegel was fairly just in his estimate of art; where he went wrong was in thinking that it could be dispensed with. He was a victim of the evolutionary concepts of his time, and applied these concepts to the human mind, where they do not work. The intellect does not develop by improving or eliminating the primary sensations or instincts, but by suppressing them. They remain submerged but clamant, and art is if anything more necessary to-day than in the Stone Age. In the Stone Age it was a spontaneous exercise of innate faculties, as art still is with young children and savages. But for civilized man art has become something much more serious: the release (generally vicarious) of repressions, a compensation for the abstraction of the intellect. I am not implying that this is the only function of art—it is also a necessary mode of acquiring a knowledge of certain aspects of reality.

When Marx turned Hegel upside down, or inside out, he accepted this evolutionary scheme—accepted, that is to say, Hegel's dismissal of art to the childhood of mankind. His dialectic of materia-

lism is a reversal of Hegel's dialectic of the spirit, but since art had already been eliminated from the domain of the spirit, it was left out of the negation of that domain. It is true that you will find in the works of Marx and Engels a few vague (and even uneasy) references to art; it is one of the ideological superstructures to be accounted for by the economic analysis of society. But there is no recognition of art as a primary factor in human experience, of art as a mode of knowledge or as a means of apprehending the meaning or quality of life.

In a similar way, that development of Hegel's thought which has accepted and affirmed his hierarchy of the spirit and has put into practice his notion of a supreme authoritarian state, this development has necessarily reduced art to a subordinate and slavish rôle. Fascism has perhaps done more and worse than that: it has insisted on a purely rational and functional interpretation of art. Art becomes, not a mode of expressing the life of the imagination, but a means of illustrating the concepts of the intelligence.

At this point, marxism and fascism, the prodigal and the dutiful sons of Hegel, meet again; and will inevitably become reconciled. There is not the slightest difference, in intention, in control and in final product, between the art of marxist Russia and the art of fascist Germany. It is true that the one is urged to celebrate the achievements of socialism, and the other to celebrate the ideals of

25

nationalism; but the necessary method is the same
—a rhetorical realism, devoid of invention, defi-
cient in imagination, renouncing subtlety and
emphasizing the obvious.

I am not going to repeat here the familiar argu-
ments against socialist realism as such. Its products
are so poor by every standard known to the history
of art that such arguments are not really necessary.
It is more important to show the positive connec-
tion between art and individual freedom.

If we consider the world's great artists and poets
—and the question of their relative greatness does
not matter: what I am going to say is true of any
poet or painter who has survived the test of time—
we may observe in them a certain development.
Indeed, to trace this development in a poet like
Shakespeare or a painter like Titian or a composer
like Beethoven is partly an explanation of the
enduring fascination of their work. We may corre-
late such development with incidents in their lives
and with circumstances of their time; these are not
without their effects. But the essential process is
that of a seed falling on fertile ground, germinating
and growing and in due course reaching maturity.
Now just as certainly as the flower and the fruit are
implicit in the single seed, so the genius of a poet
or painter is contained within the individual.
The soil must be favourable, the plant must be
nourished; it will be distorted by winds and by
accidental injuries. But the growth is unique, the

26

configuration unique, the fruit unique. All apples are very much alike, but no two are exactly the same. But that is not the point: a genius is the tree which has produced the unknown fruit, the golden apples of Hesperides. But Mayakovsky was a tree which one year was expected to produce plums of a uniform size and appearance; a few years later apples; and finally cucumbers. No wonder that he broke down under such an unnatural strain!

In Soviet Russia any work of art that is not simple, conventional, and conformist is denounced as 'leftist distortion'. Any originality is described as 'petty bourgeois individualism'. The artist must have one aim and only one aim—to supply the public with what it wants. The phrases vary in Germany and Italy, but they are to the same effect. The public is the undifferentiated mass of the collectivist state, and what this public wants is what it has wanted throughout history—sentimental tunes, doggerel verse, pretty ladies on chocolate-box lids: all that which the Germans call by the forceful word *Kitsch*.

The marxist may protest that we are prejudicing the result of an experiment. The arts must return to a popular basis and from that basis, by a process of education, be raised to a new universal level such as the world has never known. It is just conceivable —an art as realistic and as lyrical as, say, that of Shakespeare, but freed from all those personal

27

idiosyncrasies and obscurities which mar the classical perfection of his drama; or an art as classically perfect as Racine's, but more human and more intimate; the scope of Balzac allied to the technique of Flaubert. We cannot assume that the individualistic tradition which has produced these great artists has attained the highest possible peak of human genius. But is there in the history of any of the arts any evidence that such superlative works will be produced to a programme? Is there any evidence to show that the form and scope of a work of art can be predetermined? Is there any evidence that art in its highest manifestations can appeal to more than a relatively restricted minority? Even if we admit that the general level of education can be raised until there is no excuse for ignorance, will not the genius of the artist by this very fact be compelled to seek still higher levels of expression?

The artist in the U.S.S.R. is classed as a worker. That is all to the good, for the social exclusiveness of the artist has nothing to do with the quality of his work, and may be decidedly harmful. But it shows a fundamental misunderstanding of the faculty of artistic creation if the artist is treated like any other kind of producer, and compelled to deliver a specified output in a specified time. The vein of creation or inspiration is soon exhausted under such duress. That should be obvious. What is not so obvious is that the laws of supply and

demand in art are very different from those in economics. Admittedly at a certain level art becomes entertainment, and admittedly at that level it is a matter of supplying a popular article of a specified kind. But whereas we go to an entertainment to be taken out of ourselves, to forget for an hour or two our daily routine, to escape from life, we turn to a work of art in a very different mood. To express it crudely, but forcibly, we expect to be uplifted. The poet or the painter or the composer, if he is more than an entertainer, is a man who moves us with some joyful or tragic interpretation of the meaning of life; who foretells our human destiny or who celebrates the beauty and significance of our natural environment; who creates in us the wonder and the terror of the unknown. Such things can only be done by a man who possesses a superior sensibility and insight; and who by virtue of his special gifts stands apart from the mass—not disdainfully, but simply because he can only exercise his faculties from a distance and in a solitude. The moments of creation are still and magical, a trance or reverie in which the artist holds communion with forces which lie below the habitual level of thought and emotion. That is what the man of action, the politician and fanatic, cannot appreciate. They bully and shout at the artist and force him into the hubbub of practical activities, where he can only produce mechanically to an intellectually predetermined pattern. Art cannot be pro-

29

duced under such conditions, but only a dry and ineffectual semblance of it. Compelled to produce under such conditions, the more sensitive artist will despair. *In extremis*, like Mayakovsky he will commit suicide.

III

WHY WE ENGLISH HAVE NO TASTE

The title of this chapter is deliberate, and exact. I do not say that the English have bad taste—that, perhaps, might be said of other nations—but simply that they do not exercise those faculties of sensibility and selection which make for good taste. Our condition is neutral—an immense indifference to questions of art. It is true that we have magnificent museums, unrivalled in the whole world: but if we inquire into their origin, we find that they were founded 'to encourage manufactures'. It is true that we have produced great artists like Gainsborough, Constable, and Turner; but we find, when we look into their lives, that they were regarded as socially inferior beings, and were always treated with neglect. Occasionally an artist is honoured, but it is always an official artist—the President of the Royal Academy, the painter of the King's official portraits, the designer of our telephone boxes. From its very inception, our Academy has opposed origi-

31

nal talent, and never more obstinately than to-day, when we can say without fear of contradiction that not a single artist of international reputation is included among its members.

When there is no question of an art being used 'to encourage manufacture', as in the case of music, then it is completely unrecognized by the State. We have never had a national opera house, nor a national theatre; the City of London, the capital of the world's greatest empire, does not even support an orchestra.

A superficial observer jumps to the conclusion that our lack of taste is a racial defect. We are ready ourselves to confess that we are not an artistic nation (thank God!). But this, the readiest explanation, is the least true. There is the obvious contradiction of our past—our Gothic cathedrals, and all our minor arts in the Middle Ages. It can be claimed with good reason that in the twelfth century England was the most artistic country in the whole of Europe. Even in the art of music, in which we have for so long been completely impotent, we were once supreme (from the time of John Dunstable in the fifteenth century to that of Purcell in the seventeenth century). And though the gulf between the plastic arts (in which, for the purposes of this argument, we may include music) and the art of poetry is so great that it cannot be bridged by any logic, yet our poetry is sufficient evidence of an organic sensibility, of an inherent artistic nature.

We must, therefore, dismiss the racial factor as largely irrelevant, and look first into the historical factor.

But before we leave the racial question, it is worth observing that the English race is not a simple unity; apart from various subdivisions, there is the broad distinction between the Celtic and Germanic elements. About these two races we can make certain generalizations based on our knowledge of their history. We know, for example, that Celtic art through all the centuries of its separate existence was an abstract art, very vital and rhythmical, but shunning the representation of natural forms. In the modern sense, it was nonfigurative. We also know that the Germanic peoples were not given to plastic expression; their modes of thought were conceptual, and their typical art is therefore verbal. If, in the subsequent history of a country which combines two such divergent races, we find an alternation of plastic and verbal arts, it may well be due to the supremacy of one or other of these constituent racial elements.

Actually, of course, these racial elements got obscured by other factors, chiefly economic. The movement which in England brought an end to our plastic modes of expression was partly economic and partly religious; the religious aspect is known as Puritanism, the economic aspect as Capitalism, and there is now a general agreement that these two aspects were inter-active. Puritanism provided

C

Capitalism with a moral atmosphere within which it could develop unchecked by conscience and the rule of the Church. Whether the economic motive called the moral values into being, or the moral values encouraged latent impulses for the acquisition of individual power, is a problem in the dialectic of history into which we need not inquire now.

To say that England, during the last four hundred years, has shown the least evidence of artistic taste is therefore but another way of saying that during the same period England has been the most highly developed capitalist state. But such a simple materialistic explanation will not altogether suffice to explain the facts. For at other times, and in other countries, the fine arts have been used to express material wealth and power. But not in England. At the most, the successful industrialist would commission an artist to paint his portrait, and the portraits of members of his family; sometimes the patronage would be extended to include his favourite racehorse, or even a prize bull. But the notion of buying works of art for their own sake, and for the sake of the owner's aesthetic enjoyment, was confined to a few members of the aristocracy.

For an explanation of this difference between England and other capitalist countries, we must turn from social economics to social psychology. During this same period the Englishman has developed, and has shown himself consciously

34

proud of, certain characteristics which are summed up in the terms *common sense,* and *sense of humour.* The terms are closely related, and denote a certain ideal of normality to which every Englishman aspires, and to which the whole of his upbringing and education is directed. His sense of humour is his perception of any deviation from the normal. The 'gentleman' is the apotheosis of the normal. Common sense is normal sense—accepted opinion, agreed conventions, perfected habits. In his house and his clothes, in his food and his women, the Englishman of the capitalist-puritan era endeavoured to attain the normal. The definition of a well-dressed gentleman is 'one whose clothes you do not remember'; a man who in every detail, from the colour of the cloth to the number of buttons on his sleeve, is so normal that he is unnoticeable, unseen. Just as a gentleman's clothes must be distinguished by their lack of distinction, so with all his possessions. To possess works of art would be odd; to frequent with artists would be odd, for to the Englishman the artist is essentially odd, abnormal.

But the matter is deeper than this. Psychologists are beginning to suspect that this normality we value so much is no more than the most common neurosis; that normality is itself a neurosis, a retreat from the reality of life, a nervous mask. Everything in English life supports this view; the normal man *is* nervous—his laughter is an expres-

35

sion of nervousness. For English laughter (or, as I should more accurately call it, capitalist laughter) is not bodily laughter—not *belly laughter*, like the laughter of Chaucer and Rabelais; it is mental laughter, caused by an unconscious disturbance of suppressed instincts. From the same social suppression of instinct (and it is, of course, the sexual instinct that is most in question) come our other characteristics—our so-called hypocrisy, which is not pure hypocrisy, just because it is unconscious; our prudishness; our coldness in love; our lack of wit (it is significant that our wittiest writers come from Ireland, the least protestant and the least capitalist part of the kingdom).

From the same source comes the prevalent indifference to the plastic arts. For the ideal of normality alone will not explain this fact; it would be equally normal if everyone were interested in the plastic arts. But there was never any chance of that, for the same forces of repression which determine the neurosis of normality, determine also an anti-plastic tendency in the individuals suffering from such a neurosis.

The complete demonstration of this correspondence must be left to the psycho-analysts. Empirically we can see that the least suppressed societies —those least addicted to normality in conduct— are also the most plastically conscious people; the Greeks, for example. But the most convincing demonstration would be in the sphere of individual

36

psychology; for though the neurosis is determined by societal pressure, the effects reach beyond social activities and rule the individual in his purely personal modes of expression. Plastic expression is the most objective mode of expression: it involves giving fixed material expression to a personal impulse. Fear of infringing the limits of normality will tend to inhibit such a mode of expression. It will be far safer to express the individual impulse in the comparatively transitory and fluid material of music and poetry. For some obscure reason the other great Puritan section of Europe expressed its individual longings mainly in music; the English mainly in words, in poetry. But the great distinction of this poetry, compared with the poetry of other modern nations, is that it is a pure poetry. Its greatest beauty is inherent in its sound; it too is a kind of music, as far removed as possible from the visual and the plastic.

Some foreign observers, puzzled by this complete lack of the plastic sense in the English, have attempted to find it in unexpected places. A few years ago a Danish architect made an exhibition of the real, the unrecognized, English arts. The *chef d'œuvre* was the English football; there were English boots and English tennis-rackets; suitcases and saddles, and probably a water-closet. In such articles, it was maintained, we showed a supreme sense of form, of abstract *form*. It was a charming idea, but the Englishman was not

37

flattered; he laughed in his nervous manner. To him, it was a *stunt*, a good joke. 'You never know', they said to one another, 'what these foreigners will be up to next!'

So the neurosis of normality is preserved; it is impregnable. Its latest manifestation is illustrated in the term *highbrow*, which since the war has become a supreme term of abuse. For the normal man recognizes in his midst, not merely odd fellows who can be dismissed as artists, but also odder fellows who use a non-plastic medium, words, and who in poems, articles, books, and speeches, revolt against the ideal of normality; fellows who defend the artist and all his works; fellows who refuse to accept his economic system, his ideal of gentleman, his public-school education, his whole outfit of normality. Such dangerous eccentrics must be stigmatized, ridiculed, made into figures of fun— something to laugh at, something to sneer at, something to snigger at. And so the word highbrow is invented, and becomes an efficient label. You have only to call a man a highbrow to damn him in the eyes of the public, to make his books unsaleable, and his life impossible. For in his clumsy bovine way the normal man, the poor dupe of capitalism, recognizes in the highbrow a disturber of the peace; if not of the peace of society, then of the peace of his mind. 'Peace of mind' is another revealing phrase; it is the proud possession of every normal Englishman.

Those who wish to study our national neurosis must do so on the spot, but it is very doubtful if a foreigner could ever appreciate its ramifications in our society. A useful guide to its obvious aspects is that famous journal of national humour, *Punch*. There every week the highbrow is guyed, the normal is exalted, and the existence of sex is suppressed. Even the poor are resented, and their illiteracy exposed to the mirth of the public-school mind. Any daily paper will reveal the more aggressive aspects of our normality; an absolute poverty of ideas, a complete absence of any intellectual interests. But it is only in the English *home*, the Englishman's castle, as he proudly calls it, that the full horror of the neurosis will be revealed. All over the world capitalism has spread its net of mental debauchery; its standardization of taste, its imposition of material values. But in England the natural instincts have been so long deformed, that they no longer function. Sensibility is dead, and the only criterion of judgment is convention: the acceptance of a standard imposed by manufacturers, whose only criterion is profit.

The conclusion is inevitable: the conclusion we come to whichever way we turn. We are the victims of an historical process, and our lack of taste is merely our lack of social freedom. With the growth of individualism began the growth of capitalism; the public good, the common-wealth, was subordinated to private good, private wealth. Religion and

morality were adapted to the new economic order; which is to say that spiritual values were divorced from worldly values. Such is the general aspect of the change. But the individual suffers; no longer a cell within the spiritual and economic womb of the community, he develops a new kind of consciousness—the protective mechanism of a mind exposed to criticism. He grows this shell of normality, a hard opaque exterior which admits no light; beneath which the senses stir like blind maggots.

Therefore, the cause of the arts is the cause of revolution. Every reason—historical, economic, and psychological—points to the fact that art is only healthy in a communal type of society, where within one organic consciousness all modes of life, all senses and all faculties, function freely and harmoniously. We in England have suffered the severest form of capitalist exploitation; we have paid for it, not only in physical horror and destitution, in appalling deserts of cinders and smoke, in whole cities of slums and rivers of filth—we have paid for it also in a death of the spirit. We have no taste because we have no freedom; we have no freedom because we have no faith in our common humanity.

IV

ESSENTIAL COMMUNISM

When an artist, a poet or a philosopher—the kind of person we often describe as an intellectual —ventures to take part in the political controversies of his own time, he always does so at a certain risk. It is not that such questions are beneath his notice; for they involve, in the end, the very problems of art and ethics which are his particular concern. But the immediate application of general principles is rarely possible in politics, which are ruled by expediency and opportunism—modes of conduct which the intellectual cannot decently adopt. Nevertheless, in so far as his intellectual detachment, which is quite simply the scientific method, does lead to definite conclusions, to that extent the intellectual should declare his political position.

The poet, however, is in a more embarrassing situation than most of his kind. He is a creature of intuitions and sympathies, and by his very nature

41

shrinks from definiteness and doctrinaire attitudes. Pledged to the shifting process of reality, he cannot subscribe to the static provisions of a policy. He has two principal duties: to mirror the world as it is, and to imagine the world as it might be. In Shelley's sense he is a legislator, but the House of Poets is even more incapacitated than the House of Lords. Disfranchized by his lack of residence in any fixed constituency, wandering faithlessly in the no-man's-land of his imagination, the poet cannot, without renouncing his essential function, come to rest in the bleak conventicles of a political party. It is not his pride that keeps him outside; it is really his humility, his devotion to the complex wholeness of humanity—in the precise sense of the word, his magnanimity.

Special causes have intensified the indecision of my own generation. I do not wish to exaggerate the effect of the war; in my case I can see quite clearly that experience of war was not the immediate cause of political disillusion and inactivity. But it would be absurd entirely to discount the psychological effects of that experience, in so far as it was the direct experience of death and destruction. It will be recalled how Dostoevsky keyed himself up to face death one cold morning in 1849; and how he was at the last moment reprieved. It was an experience which his critics have found highly significant for his subsequent development. But that was an experience endured tens or hundreds of

times by intellectuals in the war—not by intellectuals only, of course, but by intellectuals in common with others less liable to register their psychological reactions. But in spite of such experiences, I remember that when peace came in 1918, I personally still retained the youthful idealism which had been mine in 1914. The disillusion came with the peace—with the slow-motion farce of the Treaty negotiations, with the indifference which people in power felt for the opinion of the men who had fought, with the general spread of false sentiment and hypocrisy. We had fought for Peace, for a decent world; we found we had won trophies of hatred and greed, of national passion and commercial profiteering, of political reaction and social retrenchment—not one voice, not one party, not even a Christian Church, openly declaring itself for a world of economic justice, a world free from the faults that had led us into the horrors of a world war.

Only in Russia there was a difference—a withdrawal from the scramble, a struggle for a new order of some sort. But from the depths of imposed ignorance and hopelessness, it seemed impossible to believe in the reality and the permanence of that revolution; impossible to estimate its significance.

My difficulty then was to find an immediate active rôle for the intellectual in politics. The only guide I found in this personal dilemma was the French philosopher and critic, Julien Benda. This very sharp and subtle mind had first attracted me

by an attack on Bergson, at a time when Bergson was very much my enthusiasm. He was not just to Bergson, but he weaned me from my allegiance, and my mind was fully prepared for the sterile intellectualism of Benda's subsequent works. That expression is perhaps too strong, for Benda's main contention, in such a book as *La Trahison des Clercs*, is unassailable. I shared his desire to occupy a detached position; quite simply, to be left alone to get on with my job as a poet, an intellectual, a 'clerk'. Unfortunately, as Benda admitted in his book, modern economic conditions scarcely permit the clerk to fulfil his function; and so 'the true evil to deplore in our time is perhaps not the treason of the clerks, but the disappearance of the clerks—the impossibility of leading the life of a clerk under present conditions'.

Trotsky has said that all through history the mind limps after reality. It is another way of saying that the intellectual cannot avoid the economic conditions of his time; he cannot ignore them—for they will not ignore him. In one way or another he must compound with circumstances. But to describe the exact nature of the dilemma, a metaphor more elaborate than Trotsky's is necessary. Reality is a manifold: a four-pronged magnet (of matter, sensation, intellect and intuition) with the same lines of force running through its parallel prongs.

The material organization of life is the basic fact: to that extent an intellectual can accept the

marxian dialectic. But though I admit the virtues of this method of reasoning, it would be better for me to drop all pretensions of generality and approach the matter as an intellectual, as one who has definite preferences in art and therefore in life. The marxian would call such preferences bourgeois prejudices, but that is precisely where we differ. Art is a discipline—'a symbolic discipline', as Wyndham Lewis has so well described it. Now a discipline is always practised for the purpose of directing a force into some definite channel. The discipline of art directs our sensibility, our creative energy, our intuitions, into formal patterns, symbolic shapes, allegorical fables, dramatic myths— into *works* (literally constructions) of art. But discipline, and the order it gives, does not exist for itself: it is not an end, but a means. It is not even a general or universal form which can be imposed on a multitude of phenomena. It is, rather, an individual sense of rhythm or harmony. There are metres but not metre; forms, but not form. It is only by *variation* that the artist achieves beauty. The discipline of art, therefore, is not static; it is continually changing, essentially revolutionary.

What in the attitude of our post-war Socialists probably repelled me most directly was their incapacity to appreciate the significance of the artist's approach. To me it seemed elementary that a belief in Marx should be accompanied by a belief in, say, Cézanne; and that the development of art since

Cézanne should interest the completely revolutionary mind as much as the development of socialist theory since Proudhon. I wanted to discuss, not only Sorel and Lenin, but also Picasso and Joyce. But no one saw the connection. Each isolated on his separate prong denied the relevance of the force animating the other prongs. No one could see that it was the same force that was transforming the whole of reality—of our interpretation of reality I ought rather to say. To me it seemed just as important to destroy the established bourgeois ideals in literature, painting and architecture as it was to destroy the established bourgeois ideals in economics.

In a preface to a book on the principles of modern art,[1] under the shadow, then oppressive, of the German counter-revolution, I made an attempt to dissociate revolutionary art and revolutionary politics. It is quite true, as I stated, that the majority of modern artists are 'neither Jews nor Communists, not racialists or politicians of any kind. They are just artists, and, if anything, the more *modern* they are in spirit as artists, the more disinterested and detached they become'. That cannot be denied; and my further statement is equally true—that the modernity of modern art is the result of developments within the technique and science of art. 'The great artists who have determined the course of modern art,' I wrote, 'Con-

[1] *Art Now* (Faber & Faber, 1933).

46

stable, Turner, Cézanne, Matisse, Picasso—have been, and are, singularly devoid of ideologies of any kind. They live in their vision and their paint, and follow the inevitable course dictated by their sensibility'. These statements, I repeat, are true enough, and in their context at least rhetorically justified. But in another context—the narrow context of the conditions deplored by Benda, the wider context of the general conditions of historical necessity— my statements ignore the fundamental (and fundamentally true) thesis of the marxian dialectic—the thesis expressed by my image of the four-pronged magnet.

That the marxian dialectic, as applied to art, is by no means clear in its workings is shown by the marxian critics themselves. On the one hand, we have, for example, Carl Einstein interpreting the Cubist movement in general, and Braque in particular, as an inevitable outcome of the transition from individual to collective values in society.[1] The images of reality characteristic of capitalist society must be discarded, and in their place the modern artist must create the images of a new conception of reality. Cubism in its first phase is the first step in the process of destruction, but its tectonic element—what it retains of formal structure and geometric measure—is a residue of old prejudices, a last safeguard against the unknown; it still shows a trace of the classical fear of ecstasy.

[1]*Georges Braque* (London: Zwemmer, 1934).

But in his later work an artist like Braque passes beyond such limitations, into a world of hallucination. The conscious or reasoning self is entirely destroyed, or superseded, and the painter expresses a visionary reality, devoid of any mundane (bourgeois) associations. The æsthetic criterion is overcome by the force of the creative invention; the picture becomes a 'psychogram'. And by the force of the same argument it ceases, presumably, to be a work of art! Thus the dialectical method in art criticism leaves us with an art which is not so much art as an instrument of derationalization, and we are bound to ask how such an art can ever become the synthetic expression of a proletarian culture. Mr. Einstein would argue that a proletarian art is for the moment impossible, and therefore the question does not arise. The importance of contemporary art is purely negative: it aims at a dissolution of conventional notions of reality. It clears the deck for the collective art of the future.

The examination which another marxian critic, Max Raphael, makes of another modern painter, Picasso, leads to a different conclusion.[1] Picasso is a more complicated case than Braque, but so far as his descriptive analysis of this most typical of modern artists goes, Raphael's Picasso does not differ greatly from Einstein's Braque. The difference lies in the interpretation of the facts. For

[1] *Proudhon, Marx, Picasso: trois études sur la sociologie de l'art* (Paris: Éditions Excelsior, 1933).

48

whereas Einstein sees in Braque a forerunner of the future proletarian art, Raphael finds in Picasso merely the last phase of a decadent bourgeois art— at best, a substitution of metaphysical intuition for impressionistic sensualism; but definitely within the European tradition, and definitely reactionary. His recourse to negro art, to classical art, to 'super-reality', are so many flights from reason—from the implications of a rational view of life. His art is not a simple eclecticism, but a new form of reactionary bourgeois art. The series: negroid, antique, medieval —all phases of Picasso's development—expresses first his fear of tradition, then his precipitate flights back into its bosom. According to this view, Picasso's many-sided development only displays so many futile efforts to solve the problem left unsolved by the nineteenth century—the creation of an art based on economic reality, on the emergent social forces of the modern period. Which is to say no more than that Picasso has remained completely unconscious of the class struggle—a supposition which has not been confirmed by his attitude towards the present struggle in Spain.

Trotsky somewhere warns us of the necessity, the difficult necessity, of distinguishing between the true and the false revolutionary. That discrimination is just as necessary in modern art as in modern politics. In the modern tradition of painting—ever since painting revolted, like poetry, against the artificiality and irrelevance of the academic tradi-

tion of the eighteenth century—there are a number of individual artists whose aims and whose achievements have step by step built up a new conception of reality—a conception of reality totally opposed to the bourgeois standards of the period. Constable began a movement which includes Courbet, Daumier, Van Gogh, Cézanne, and Seurat. The perspective this side of Cézanne is more difficult to see, but in that tradition I would place an artist so coherent and so consistent as Juan Gris, and for the present the tradition is in the miraculous hands of Picasso. Against that tradition, catering for quite a different public (for a *bourgeois* public, in short) you have not only the commonplace art of the academies, but various aspects of dilettantism (neo-classicism, pseudo-romanticism, impressionism) all of which have little to do with the art of the future. The main tradition, the only tradition which is revolutionary in essence, in its fundamental vision of life, that is the tradition which must be integrated with the social revolution.

The issue, as presented by a consideration of these facts, has clearly to do with the relation of the individual to society. The artist is always an individualist, in some sense. But the sense is very different at different times. It is not the same sense in the twelfth century and in the nineteenth century. There is, in fact, an important distinction to be made between individuality and individualism—between the unique capacity of the individual as

artist and what Gorky calls 'the instinctive anarchy of the individual', which latter meaning is the basis of Plato's objection to the poet. I am not sure that this distinction will not resolve, in the end, into the general contrast between classicism and romanticism, but I do not, on this occasion, wish to be tempted by such a dangerous analogy. My immediate object is to suggest that the main tradition of modern art is a coherent attitude towards reality —that reality which, to quote Gorky once more, 'is created by the inexhaustible and intelligent will of man'.

Trotsky, who has dealt with these questions more intelligently than most modern critics, has a clear definition of the artist's individuality. 'The truth is', he writes in *Literature and Revolution*,[1] 'that even if individuality is unique, it does not mean that it cannot be analysed. Individuality is a welding together of tribal, national, class, temporary, and institutional elements, and, in fact, it is in the uniqueness of this welding together, in the proportions of this psycho-chemical mixture, that individuality is expressed. One of the most important tasks of criticism is to analyse the individuality of the artist (that is, his art) into its component elements, and to show their correlations. In this way, criticism brings the artist closer to the reader, who also has more or less of a "unique soul",

[1]Trans. Rose Strunsky (London: Allen & Unwin, 1925), pp. 59–60.

"artistically" unexpressed, "unchosen", but none the less representing a union of the same elements as does the soul of the poet. So it can be seen that what serves as a bridge from soul to soul is not the unique, but the common. Only through the common is the unique known; the common is determined in man by the deepest and most persistent conditions which make up his "soul", by the social conditions of education, of existence, of work, and of associations.'

With this passage I should like the reader to compare Gorky's statement on the same subject, in a letter from which I have already quoted[1]:

'Individualism sprang from the soil of "private ownership". Generations upon generations of men have created collectives, and always the individual, for one reason or another, has stood apart, breaking away from the collective and at the same time from reality where the new is ever in the making. He has been creating his own unique, mystical, and incomprehensible god, set up for the sole purpose of justifying the right of the individual to independence and power. Here mysticism becomes indispensable, because the right of the individual to absolute rule, to "autocracy", cannot be explained by reason. Individualism endowed its god with the qualities of omnipotence, infinite wisdom and absolute intelligence—with qualities which man would

[1]'Reply to an Intellectual,' in *On Guard for the Soviet Union.* English trans. (London: Martin Lawrence, 1933), p. 90.

like to possess, but which develop only through the reality created by collective labour. *This reality always lags behind the human mind*, for the mind which creates it is slowly but constantly perfecting itself. If this were not so, reality would, of course, make people contented, and the state of contentment is a passive one. Reality is created by the inexhaustible and intelligent will of man, and its development will never be arrested.'

I must apologize for these long quotations, but this question of the relation of the individual to the collective society of which he is a member is the fundamental issue, in art as well as in politics. It is the fundamental question *within* religion too, for what is the Reformation but the affirmation of the autocratic will of the individual against the collective rule of the Church? Philosophically it is the issue between Scholasticism and Cartesianism, between materialism and idealism. But before passing on to the general issue, I should like to point out a curious contradiction between the statements quoted from Trotsky and Gorky— something more serious than their (or their translators') inconsistent use of the words 'individuality' and 'individualism'. I have previously quoted Trotsky's blunt summary of his general point of view: 'all through history, mind limps after reality'. 'Reality,' says Gorky in the sentence I have italicized, 'always lags behind the human mind'. Presumably these two statements could be reconciled by

the dialectical method, for dialectics, in the words of Lenin,[1] is 'the study of how there can be and are ... identical opposites'.

Dialectics apart, there is a sense in which both Gorky and Trotsky may be right. The relation between mind and reality, between the individual and the community, is not one of precedence; it is more one of action and reaction, a process of tacking against the wind. The current of reality is strong, and troubles the mind; but the mind embraces this contrary force, and is lifted higher, and carried farther, by the very opposition. And so with the individual and the community. Complete freedom means inevitable decadence. The mind must feel an opposition, must be tamped with hard realities if it is to have any blasting power.

For this reason I think we must look askance at the word 'liberal', preferring perhaps the title 'realist'. A realist I would define as a man who has learnt to distrust any term to which he cannot attach a perfectly definite meaning. He particularly distrusts those ideological phrases, catchwords, slogans, and symbols under cover of which most of the political activities of to-day take place. He has a very bitter memory of phrases like 'a war to end war', and 'making the world safe for democracy'. As a realist I look with intense suspicion on words like 'democracy', 'race', 'nation', 'empire',

[1]Quoted by Max Eastman: *Artists in Uniform*, p. 189.

'proletariat', 'party', 'unity', 'decency', 'morality',
'tradition', 'duty', etc. I prefer words like 'reason',
'intelligence', 'order', 'justice', 'action', and 'objec-
tive'; words equally abstract, but representing
tidier habits of mind. The word 'liberalism' would
naturally be suspect; but it has associations with
the word 'liberty', and in the name of liberty most
of what I value in life and literature has been
achieved. What, then, of this word 'liberty'?

I admit that it represents an idea to which I am
passionately attached; at the same time it is a
word which I have looked at with a disenchanted
eye. I know that it denotes different things to
different people, and that many interpretations of
it are worthless. In short, I know that the idealistic
implications of the word are quite devoid of reality.
Liberty is always relative to man's control over
natural forces, and to the degree of mutual aid
which he finds necessary to exert this control. That
is why, in face of the material problems of exis-
tence, the ideal of anarchy becomes the practical
organization of society known as anarcho-syndica-
lism. Government—that is to say, control of the
individual in the interest of the community—is
inevitable if two or more men combine for a com-
mon purpose; government is the embodiment of
that purpose. But government in this sense is far
removed from the conception of an autonomous
State. When the State is divorced from its imme-
diate functions and becomes an entity claiming to

control the lives and destinies of its subjects—then liberty ceases to exist.

What might be called the tyranny of facts—the present necessity which most of us are under to struggle for our very existence, our food, our shelter and other no less essential amenities of life— this tyranny is so severe that we ought to be prepared to consider a restriction of liberty in other directions if in this respect some release is promised. But it is no less essential to realize that this tyranny is to a large extent due to the inefficiency of our present economic system, and that liberty now and always depends on a rational organization of production and distribution.

In all that concerns the planning of economic life, the building up of a rational mode of living in a social community, there can be no question of absolute liberty. For, so long as we live in a community, in all practical affairs the greatest good of the greatest number is also the greatest good of the individual. As individuals we must be willing to surrender all material rights—to put all our property into the common fund. Even if we have wealth, we can do this with a happy conscience, for material possessions were always a menace to spiritual liberty. To a certain degree, therefore, we must accept the State as an economic structure, as an efficient machine designed to facilitate the complex business of living together in a community. But actually this rational and practical concept of the

State—a concept that need be nothing but rational and practical and strictly functional in its scope— is extended and combined with various distinct ideologies: in Russia with the marxian ideology of dialectical materialism, in Italy with the ideology of nationalism, in Germany with the even more dangerous ideology of race. In the name of these ideologies, the intellectual liberty of the individual is sacrificed. And that is too much. Whether we accept Trotsky's or Gorky's 'identical opposite', whether we regard the individual as determined by the community, or the community as determined by the individual, the sacrifice is in either case intolerable.

* * *

Intellectual liberty—the liberty to pursue individual trends of thought and to publish these for the interest or amusement of our fellow-men—is not defended by me in a spirit of vague idealism. The political ideology of liberty is liberalism, or *laissez-faire*, which is the doctrine most suited to a predatory capitalism. But the pure doctrine of liberty, or libertarianism, will be a living doctrine as long as our civilization survives; for on our liberty depends the life of our civilization. And depends in the most practical and demonstrable way. The proof must naturally be historical; and from history, in all its aspects, emerges the incontrovertible law which Mill expressed in these words: 'The initiation of all wise or noble things comes and

must come from individuals; generally at first from some one individual'. Or, negatively: 'The despotism of custom is everywhere the standing hindrance to human advancement, being in unceasing antagonism to that disposition to aim at something better than customary, which is called, according to circumstances, the spirit of liberty, or that of progress or improvement'. I am not as fond as Mill of the word 'progress'; it is not very real as a concept applied to the last five thousand years of history, and it is foolish to indulge in anything but relatively short-term policies for the human race. But I do cling to the fact of vitality; for on the vitality of a civilization depends just simply the will to live—at least, for an intellectual. I know that some of my contemporaries can complacently sacrifice this will; but that is a form of spiritual treachery in which I have no desire to participate. In history, the stagnant waters, whether of custom or of despotism, support no life; life depends on the agitation set up by a few eccentric individuals. For the sake of that life, that vitality, a community must take certain risks, must admit a modicum of heresy. It must live dangerously if it would live at all.

At first sight it would seem that countries like Germany, Italy, and Russia satisfy this condition. One could hardly complain of social stagnation in any of them; and the effects of intellectual stagnation require a few years to show themselves. The economic issues are in such countries confused by

political opportunism. But one issue, and one only, emerges when all temporary and tactical considerations have been dismissed: the issue between capitalism and communism. Even fascism, if we are to believe its theoretical exponents, is socialistic, the aim being to control the means of production and distribution for the general benefit of the community, and therefore to restrict all forms of monopoly and individual power. The essential doctrine of all reforming parties is communism; they only differ in the sincerity with which they profess the ideal, and in the means they adopt to realize it. Some find the means more attractive than the end.

But I must explain what is meant by this essential communism, for it has little to do with the existing communist parties. In the famous Manifesto of the Communist Party, published by Marx and Engels in 1848, the theory of communism was summed up in a single sentence: *Abolition of private property*. There is, it will at once be seen, nothing ideological, nothing in any way mystical, about such a doctrine. But one might criticize it for being merely negative in expression. *The provision of equal and sufficient property for all*, or simply *The abolition of poverty*, gives a more positive expression to the same aim. The doctrine is fundamentally single and practical and can be given an economic sanction if an ethical one is regarded as too idealistic.

The difficulty is to agree on a definition of terms,

and on the practical application of theory. There, I think, the politicians fail us. All alike refuse to make a realistic analysis of the factors involved. They talk of capitalism, but make no distinction between financial capital and industrial capital, between liquid and fixed assets, between the bank and the factory. They talk of the proletariat or the working class, without realizing that these are only empty ideological phrases. There is a proletariat in Russia (or was), but if we have any imagination at all, or any knowledge of the difference between the two countries, we must recognize that the word 'proletariat' has no realistic application for us; for us the term is mythical. In Russia the proletariat is a social reality; it is possibly a reality in Japan and China, and in those countries we may perhaps legitimately expect a communist revolution on the Russian plan. But in this country, and in advanced industrial countries all over the world, the proletariat is becoming more and more insignificant. It is the Ten Little Nigger Boys of our economic system: unit by unit rejected by the dehumanizing machine. Some of it goes into the skilled technical classes, some into the petty bourgeois class, some into that growing class, the permanently unemployed. Immense developments of energy and invention since Marx's day have completely transformed the economic situation; so transformed it that, frankly, a revolution of the kind which that prophet envisaged is no longer necessary, and will

never be desired by a coherent proletariat in this country. Naturally the abolition of poverty and the consequent establishment of a classless society is not going to be accomplished without a struggle. Certain people have to be dispossessed of their autocratic power, and of their illegitimate profits. But now that the true drift of capitalism has become so evident in the world-wide paradox of 'poverty in the midst of plenty', the real evil stands revealed; and against that evil, the money monopoly, not one class but the whole of the rest of the community will be united.

No man in his senses can contemplate the existing contrasts with complacency. No one can measure the disparity between poverty and riches, between purchasing power and productive capacity, between plan and performance, between chaos and order, between ugliness and beauty, between all the sin and savagery of the existing system and any decent code of social existence (Christian or moral or scientific)—no man can measure these disparities and remain indifferent. Our civilization is a scandal and until it is remade all our intellectual activities are vain. As poets and painters we are futile until we can build on the basis of a unified commonalty. Again I do not imply any mystical factors; I merely want to point to the obvious truth that you cannot play to an audience in an uproar—however attentive the people in the stalls.

<p style="text-align:center">* * *</p>

<p style="text-align:center">61</p>

The problem, in its broad outlines, is simple enough. On the one side we have mankind, needing for its sustenance and enjoyment a certain quantity of goods; on the other side we have the same mankind, equipped with certain tools, machines, and factories, exploiting the natural resources of the earth. There is every reason to believe that with modern mechanical power and modern methods of production, there is or could be a sufficiency of goods to satisfy all reasonable demands. It is only necessary to organize an efficient system of distribution and exchange. Why is it not done?

The only answer is that the existing inefficient system benefits a small minority of people who have accumulated sufficient power to maintain it against any opposition. That power takes various forms—the power of gold, the power of tradition, the power of inertia, the control of information—but essentially it is the power to keep other people in a state of ignorance. If the superstitious credulity of the masses could be shaken; if the fantastic dogmas of the economists could be exposed; if the problem could be seen in all its simplicity and realism by the simplest worker and peasant, the existing economic system would not last a day longer. The creation of a new economic system would take more than the following day; but it would be better to begin with a revolution, as in Spain, than to go through the slow-motion agony of a so-called 'transitional period'. A transitional period

is merely a bureaucratic device for postponing the inevitable.

The inevitable is the classless society—the society without a bureaucracy, without an army, without any closed grade or profession, without any functionless components. A hierarchy of talent, a division of labour, there must be; but only within the functional group, the collective organization. Whether responsibility and efficiency should be rewarded is a nice problem for the future; what is certain is that it should not be rewarded by any kind of money or tokens of exchange which could give one man power to command the services of another outside the collective organizations. The tokens of exchange should only be redeemable in goods, and should have a limited period of validity. The hoarding of money and all forms of usury should be regarded as unnatural vices, tendencies to be prevented by the psychologist in infancy. The only object of work should be immediate enjoyment; and there should be no work done in excess of immediate needs, except such as may be required to insure against the risks of natural calamities. Work in general should be subordinated to the enjoyment of life—it should be regarded as a necessary interval in the day's leisure. But this very distinction between work and leisure is born of our slave-ridden mentality; the enjoyment of life is the activity of life, an undifferentiated performance of mental and manual functions: things done and

things made in response to a natural impulse or desire.

The phrase, 'a classless society', no doubt has terrors for any thoughtful person. It calls up immediately the image of a dull level of mediocrity: no masters and no servants, no palaces and no cottages, no Rolls-Royces and no donkey-carts— all one uniform scale of self-sufficient individuals, living in block-houses, travelling in uniform Fords along endless uniform roads. I admit that a society in which every individual has an inalienable right to a living dividend will, by the abolition of poverty, create some pretty problems for the snobs of Mayfair and Kensington, even for the snobs of every suburban villa. But even if, eventually, the purchasing power in the hands of the community were more or less equally divided, the spending of this income would not produce a uniformity of life, simply because there is no uniformity of desire. Uniformity is an unintelligent nightmare; there can be no uniformity in a free human society. Uniformity can only be created by the tyranny of a totalitarian régime.

The only kind of levelling we need really fear is an intellectual levelling. But again we must take into consideration the facts—that is to say, human nature. The society I desire and will and plan is a leisure society—a society giving full opportunity for the education and development of the mind. Mind only requires time and space—to differentiate

itself. The worst conditions of intellectual uniformity and stupidity are created by conditions of poverty and lack of leisure. The ordinary man under our present unjust system has to have his education stopped before his mind is fully opened. From the age of fourteen he is caught up in an endless treadmill; he has neither time nor opportunity to feed his undeveloped senses—he must snatch at the diuretic pabulum of the newspapers and the radio, and as a consequence, tread the mill with more urgency.

In the classless leisure society, the mind of every individual will have at least the opportunity to expand in breadth and depth, and it will be one of the main functions of government to supply the instruments of culture. In the society of the future, the most important public services will be the Ministries of Education and of Fine Art. Whether the circumstances will lead to an intensified religious life is a speculation I must leave to others; but I will present those who are interested in this aspect of the question with the following dilemma: if religion is a consolation or compensation for the insufficiencies of this vale of tears (the 'romanticism of pessimism,' as Benda calls it), then no doubt it will suffer by the abolition of poverty; if, on the other hand, religion is the life of contemplation, the fruit of pure meditation, spiritual joy, then it cannot help but prosper in a society free from poverty, pride, and envy.

V

THE NECESSITY OF ANARCHISM

There is nothing to be gained by disguising the fact that recent events in Russia have created among socialists, if not a state of open disillusionment, at any rate some degree of secret embarrassment. It began with the first of the great trials for treason in Moscow; for whatever the rights and the wrongs of the parties in question, we were left with this inescapable dilemma: either the accused were guilty, in which case their treason was evidence of a lack of unity within the Soviet Union—even of a widespread revolt against the policy of Stalin; or they were innocent, in which case Stalin becomes a sinister dictator in no way distinguishable from Hitler or Mussolini. Meanwhile various other tendencies in Russia, which we had condoned so long as they could be ascribed to the stress of intensive economic production, became stabilized and to some extent codified in the new constitution. These tendencies I shall presently refer to in more detail.

But it is not in Russia alone that disturbing events have taken place. There have been very significant developments in Spain. There we have seen the outbreak of a fascist revolt against a democratic socialist government, and the emergence, in defence of that government, not of any clearly defined marxist party on the Russian model, but of a heterogeneous group of parties of the left who are barely kept from flying at each others' throats by the danger which threatens them all alike. Including federalists and anarchists, these parties of the left in Spain are overwhelmingly opposed to a totalitarian state on the Russian model. Even if, in the course of the struggle against fascism, owing to their command of Russian aid and their superior discipline, the communists gain eventual control of the machine of government, we may be sure that the end of the civil war will be the end of that advantage. The demand for provincial autonomy, for syndicalist autonomy, for the abolition of the bureaucracy and the standing army, springs from the deepest instincts of the Spanish people.

The journals of this country, and the leading political publicists who serve them, have shown little comprehension of this situation in Spain. At the mention of anarchism the bourgeois press conjures up a bearded figure wearing a wide-brimmed hat and carrying a home-made bomb in his pocket, and is quite capable, it seems, of crediting Spain with two million such melodramatic characters. As

67

for our socialist pressmen, either they have assumed that anarchism was buried when Marx defeated Bakunin at the Hague Congress of 1872, and they will not write or act on any other assumption; or, knowing that in Italy and Spain anarchism has never died, they have deliberately obscured the issue, pretending that anarchism was merely an infantile disorder of the Latin temperament, and not to be taken seriously. They now watch the outcome of the Spanish struggle with some anxiety, for what if, after all, anarchism became a power in one European country? What if, in the west of Europe, there came into existence a form of socialism which presented an alternative to the form of socialism already established in the east? At present we accept Stalin's régime and the Third International because, whatever its faults and shortcomings, it is the only established system of communism in the world. What if, in Spain, another system were established which claimed to be a more essential kind of communism?

We cannot anticipate the events, but we can at least prepare our minds for an unprejudiced reception of them. My only object at present is to contrast some of the transitional aspects of communism in Russia with some of the aspirations of anarchism in Spain.

I began by speaking of a general state of disillusionment or doubt among socialists, but I have

already confessed that my own misgivings were first aroused by the suicide of Mayakovsky, which took place in 1930. I know that most communists, even those among them who might claim to be fellow-poets, have been able to explain away this suicide to their own satisfaction; in view of the magnitude of the Russian experiment a certain amount of rough-shod trampling over the tender shoots of poetry was perhaps to be expected. But if it had been merely a case of clumsiness, it might have been met with forgiveness. It soon appeared, however, that the 'liquidation' of such poets as Mayakovsky was to be justified on aesthetic grounds. They were accused of formalism, individualism and subjectivism, and all true communist poets were required to subscribe to a doctrine of realism, naturalism, and objectivity. Political power was invoked to enforce an aesthetic programme; time-serving journalists like Radek and Bukharin were called upon to relate this aesthetic programme to the true gospel of dialectical materialism—an exercise in scholasticism which they carried out with medieval thoroughness.

The recent fall of Radek and Bukharin has not brought to an end the persecution of poets and artists. At the present moment, Pasternak, since Mayakowsky's death the most important poet in Russia, languishes in prison, and Shostakovich, one of the few modern composers with a European reputation, is in disgrace. There is no question of

their complicity in any political manœuvres; their only sin is 'formalism', by which is meant their inability to degrade their art to the level of the sensibility of the masses.

It will be objected that these are relatively small incidents to pit against the achievements—military, industrial, and educational—of the Soviet Union. But that is to adopt a short-sighted view of what it takes to make a civilization and a culture. When Stalin and his works are trampled into the dust by new generations of men, the poetry of Pasternak and the music of Shostakovich will still be as real as on the day they emerged from the minds of their creators.

This should make my own fundamental attitude clear enough. I do not want to pose as a politician. I am not ignorant of political economy nor of political philosophy, but I am not advancing a political doctrine. To accuse me of Trotskyism, for example, is quite meaningless. For Trotsky as a writer and a dialectician I have a considerable admiration. In his political aspirations and intrigues I have not the slightest interest; and I have no guarantee that a doctrinaire like Trotsky would be any improvement on a doctrinaire like Stalin. For fundamentally I renounce the whole principle of leadership and dictatorship to which both Stalin and Trotsky are personally committed.

The essential principle of anarchism is that mankind has reached a stage of development at which

it is possible to abolish the old relationship of master-man (capitalist-proletarian) and substitute a relationship of egalitarian co-operation. This principle is based, not only on ethical grounds, but also on economic grounds. It is not merely a sentiment of justice, but also a system of economic production. The ethical anarchism of Bakunin has been completed by the economic syndicalism of Sorel. There may still be ethical anarchists of the Tolstoyan type who are convinced that we must reverse the whole tendency of our technical development and return to handcraft and individual workmanship. But the more realistic anarchist of to-day has no desire to sacrifice the increased power over nature which modern methods of production have developed. And actually he has now realized that the fullest possible development of these methods of production promises a greater degree of individual freedom than has ever hitherto been secured by mankind.

Marx and Engels always represented communism, in its final stage, as a free association of co-operators, exempt from the control of any central government or bureaucracy. Engels describes the State as 'withering away'—it is one of the key passages in the formulation of Marxism:

'The proletariat seizes State power, and then transforms the means of production into State property. But in doing this, it puts an end to itself

71

as the proletariat, it puts an end to all class diffe-rences and class antagonisms, it puts an end also to the State as the State. . . . As soon as there is no longer any class of society to be held in subjection; as soon as, along with class domination and the struggle for individual existence based on the former anarchy of production, the collisions and excesses arising from these have also been abolished, there is nothing more to be repressed, and a special repressive force, a State, is no longer necessary. The first act in which the State really comes forward as the representative of society as a whole—the seizure of the means of production in the name of society—is at the same time its last independent act as a State. The interference of a State power in social relations becomes superfluous in one sphere after another, and then becomes dormant of itself. Government over persons is replaced by the administration of things and the direction of the processes of production. The State is not "abolished", *it withers away.*'

As if conscious that this theory of Engels' might be treated as a brilliant paradox and no more, Lenin himself wrote a special treatise, *The State and Revolution*, which he finished between the March and October revolutions, 1917, with the express purpose of substantiating Engels. It is true that he is also concerned to make clear that a revolution is a precedent and necessary condition for this withering away of the State; the proletariat

must seize State power before it can establish the conditions for its gradual dissolution. But that is not in question. What we are to note is Lenin's most explicit affirmation of the non-governmental nature of the final phase of communism. In his own words:

'From the moment when all members of society, or even only the overwhelming majority, have learned how to govern the State *themselves*, have taken this business into their own hands, have "established" control over the insignificant minority of capitalists, over the gentry with capitalist leanings, and the workers thoroughly demoralized by capitalism—from this moment the need for any government begins to disappear. The more complete the democracy, the nearer the moment when it begins to be unnecessary. The more democratic the "State" consisting of armed workers, which is "no longer a State in the proper sense of the word", the more rapidly does *every* State begin to wither away.

'While the State exists there is no freedom. When there is freedom, there will be no State.'

In view of such explicit statements, it is not possible for the present rulers in Russia to do other than announce their own approaching dissolution. Stalin himself, in his speech to the Sixteenth Congress of the U.S.S.R., said:

'We are for the withering away of the State. . . . To keep on developing State power in order to pre-

pare the conditions for the withering away of State power—that is the marxist formula.'

Or is there an equivocation in this utterance? We are for the withering away of the State—yes, but first we must develop the State to unheard-of dimensions in order to prepare the conditions for this withering away. Like the frog in the fable, the State must inflate itself till it bursts. Certainly since the revolution of 1917 the State machine has year by year grown in size and importance, and the hope that it will eventually wither away, which must have replaced the hope of Paradise in the hearts of all true Russians, becomes everyday more remote. For in the very process of developing the power of the State new classes are born which usurp this power and use it to oppress the people at large.

In Russia this decisive turn was taken—not with any appeal to first principles, not with any overt consciousness of the significance of the event— when payment by piece-work was re-established in the Soviets. This step was justified, as all departures from the true doctrine of communism have been justified, on the grounds of economic necessity. It became apparent that the socialist system could only be established in Russia by increasing the rate of industrial production. In a socialist state it is not possible to increase the level of individual well-being, however equally you divide the common goods, unless you increase the total

amount of production.[1] Now whether because the actual machinery of production in Russia is inadequate, or because the natural aptitude of the Russian for production is below the general standard, the fact is that the productivity of labour in Russia has been, and still is, lower than the productivity of labour in capitalist countries like Great Britain, Germany, and the United States. There are many explanations, but the one which has most significance is the one which Stalin has not failed to use—the fact that man will not produce to the full extent of his abilities unless he can thereby gain some advantage over his fellow men. This allegation—I am going to submit that it is no more than an allegation—if it is accepted, undermines the whole doctrine of communism. For what, if it is true, becomes of the most sacred of all marxian formulas: *From each according to his abilities, to each according to his needs?* That phrase means, if it means anything at all, that each member of the community will work in accordance with his individual will and inclination—his physical and psychological capacity—and that no compulsion will be used to make him work beyond his abilities. The *necessity*, as Lenin put it, of observing the simple, fundamental rules of everyday social life in common will have become a *habit*.

[1]Theoretically there is the alternative of maintaining the amount of production and decreasing the population, but that too involves an increased *rate* of production.

Have we, then, to admit that in Russia in particular or in the world in general this sacred formula has to be abandoned? Have we to come to the humiliating conclusion that without compulsion men will not work sufficiently to satisfy the total requirements of the, community? Have we to assume that with all the vast increase of means and methods of production—collective farms, tractors, standardization, rationalization, electric power—that with all these gifts civilized man is no better off than the savage, who even in the arctic wastes will work according to his abilities and receive according to his needs?

Such a conclusion is impossible. We must rather conclude that there is something very wrong with the state of Russia. The most charitable assumption is that the country is still in such a backward condition of economic development that it must resort to methods of labour exploitation which even in capitalist countries are rapidly disappearing. The uncharitable assumption is that such a method of exploitation has been introduced to subsidize a scarcely disguised system of state capitalism, with the bureaucracy as a privileged controlling class. Trotsky and other critics of the Stalinist régime already make that charge, and point to many subsidiary proofs. It is certainly difficult, on any other assumption, to justify such measures as the rehabilitation of the rouble, the new laws protecting private property, the revival

of military titles and decorations, the establishment of separate military colleges and special schools for the children of the privileged classes.

But it is not my intention to detail all the shortcomings of the present régime in Russia; some of its failings are admittedly of a transitional nature, and others can be set off against the manifold benefits which communism has brought to the Russian people. But even if the system were perfect in its functioning, it would still be in complete contradiction with the principles of anarchism. For essential to the communist policy as it has developed in Russia is the concept of leadership—a concept which it shares with fascism, let it be noted. It may be, of course, that men of destiny like Lenin and Stalin, Hitler, and Mussolini, are created by historical events—that their stature is, as it were, inflated by special economic conditions. But however produced, communists as well as fascists never doubt the necessity, nor even the desirability, of such leaders. They are extolled as the creators and the controlling minds of the political movements of which they are the figureheads.

Freud has shown what an important part is played by the leader in the psychology of the group. 'The uncanny and coercive characteristics of group formations, which are shown in their suggestive phenomena, may . . . be traced back to the fact of their origin from the primal horde. The leader of the group is still the dreaded primal

77

father; the group still wishes to be governed by unrestricted force; it has an extreme passion for authority; in Le Bon's phrase, it has a thirst for obedience.' As for the leader himself, 'he, at the very beginning of the history of mankind, was the Superman whom Nietzsche only expected from the future. Even to-day the members of a group stand in need of the illusion that they are equally and justly loved by their leader; but the leader himself need love no one else, he may be of a masterly nature, absolutely narcissistic, but self-confident and independent.'[1]

I would define the anarchist as the man who, in in his manhood, dares to resist the authority of the father; who is no longer content to be governed by a blind unconscious identification of the leader and the father and by the inhibited instincts which alone make such an identification possible. Freud, who at this point is merely adopting the ideas of Otto Rank, sees the origin of the heroic myth in such a longing for independence. 'It was then, perhaps, that some individual, in the exigency of his longing, may have been moved to free himself from the group and take over the father's part. He who did this was the first epic poet; and the advance was achieved in his imagination. This poet disguised the truth with lies in accordance with his longing. He invented the heroic myth. The hero

[1]Sigm. Freud: *Group Psychology and the Analysis of the Ego.* Eng. trans. (1922), pp. 99–100, 93 and *passim.*

was a man who by himself had slain the father—
the father who still appeared in the myth as a
totemistic monster. Just as the father had been the
boy's first ideal, so in the hero who aspires to the
father's place the poet now created the first ego
ideal.' But the further step which the anarchist
now takes is to pass from myth and imagination to
reality and action. He comes of age; he disowns the
father; he lives in accordance with his own ego-
ideal. He becomes conscious of his individuality.

How far the communist is from taking that
further step in human development is shown, not
merely by historical events in Russia, but also by
their theories and pronouncements. There is no
need to repeat the numerous exaltations of leader-
ship which appear with monotonous regularity in
the communist press; but it is interesting to note
the deliberate adoption of the leadership principle
by a communist who happens at the same time to
be a psycho-analyst—I refer to Mr. R. Osborn's
recent book on *Marx and Freud*. Mr. Osborn gives
an account of Freud's theory of leadership and
then, without once questioning the necessity for
the particular type of group organization which
demands a leader, assumes that the need for leader-
ship is universal, and that the Communist Party
would be well advised to adopt a strategy based on
a realization of this fact. 'The first necessity', he
says, 'would seem to be to crystallize the leadership
in the shape of a leader—someone who may be

79

referred to in such terms as will awaken the required emotional attitudes. In other words, we must idealize for the masses some one individual to whom they will turn for support, whom they will love and obey.' He gives Lenin and Stalin as admirable examples of such individuals and concludes that 'it is a psychologically sound measure to keep such people before the masses as an incentive and guide to the overcoming of difficulties on the road of social progress'. He declares that the problem must be tackled 'in a consciously-thought-out manner which utilizes all that modern psychology has to offer on the subjective characteristics involved. . . . If Hitler and Mussolini, by deliberate publicity and propaganda methods, can be presented as saviours of the people, so too can Communist leaders.'

I will not comment on the somewhat scornful attitude towards the 'masses' which such tactics imply. The dictatorship of the proletariat is one thing—it is a fine-sounding phrase which conjures up a picture of politically conscious individuals acting rationally and objectively; but what has it in common with this other picture of a dumb horde which blindly worships and obeys a modern and scientifically concocted equivalent of the primitive tyrant? Surely it is the depth of political despair to conclude that there is no possible escape from this particular psychological pattern. We know that the mass of people is psychologically disposed to accept

80

a leader or dictator. We are all children who are willing to leave our destinies in the hands of a father, and discover too late that this father is tyrannical. If we revolt, must it be merely for the purpose of placing another father in the place of the one disposed? Is it not rather time that we grew up, became individually conscious of our manhood, asserted our mutual independence?

If now we pass from the people to the leader, we are forced to recognize the complementary fact that *power corrupts*. It does not matter whether the chosen leader was originally a man of good intentions, like Stalin or Mussolini; or whether he was a vulgar and pretentious demagogue like Hitler: it is only a rare superman, such as Lenin may have been, who is by nature so essentially humble that he is incorruptible. It is not necessary to enlarge on this truth; it is a commonplace of history, and has been embodied in the ethical teachings of all the great religions. In Greek mythology this corruption in tyrants was recognized as a particular kind of sin (*hybris*) and visited by inevitable retribution.

The obsessive fear of the father which is the psychological basis of tyranny is at the same time the weakness of which the tyrant takes advantage. We all know the spectacle of the bully goaded into sadistic excesses by the very docility of his victim. The tyrant or dictator acts in exactly the same way. It is not psychologically credible that he should act

in any other way. The only alternative to the principle of leadership is the principle of co-operation or mutual aid; not the father-son relationship which has persisted from primitive times, but the relationship of brotherhood; in political terms, the free association of producers working for the common good. This is the essential doctrine of anarchism, and far from having been discredited by marxian economics or the achievements of the Soviet Union, it has everywhere received overwhelming confirmation in the events of the last twenty years, until we may now claim that the realization of this principle of brotherhood is the only hope of civilization.

I do not say that we must go back to Bakunin—you find many noble sentiments in his writings, and his life was immensely heroic, but he has no practical message for the present age. Kropotkin, who was also a noble and heroic figure, is more practical, but his plans too have been overtaken by the intensive development of modern methods of production. Since Kropotkin's time anarchism has evolved to meet modern conditions, and as a practical policy is known as syndicalism; wherever anarchism is a considerable political force, as in Spain, it is combined with syndicalism. Anarcho-syndicalism is a clumsy mouthful, but it describes the present-day type of anarchist doctrine.

In this country we have the embryo of such a policy in the shop-stewards' movement, and even in

the constituency groups of the Labour Party. These developments are devolutionary—revolts against centralization and bureaucratic control—and as such essentially anarchist. For the anarchist objects, not merely to the personal tyranny of a leader like Stalin, but still more to the impersonal tyranny of a bureaucratic machine.

What is wrong with bureaucracy? In the vast and extremely complicated conditions of modern civilization, is not a bureaucracy necessary merely to hold that civilization together, to adjust relationships, to administer justice and so on?

Actually, of course, in a society of rich and poor nothing is more necessary. If it is necessary to protect an unfair distribution of property, a system of taxation and speculation, a monopolist money system; if you have to prevent other nations from claiming your ill-gotten territorial gains, your closed markets, your trade routes; if as a consequence of these economic inequalities you are going to maintain pomp and ceremony, ranks and orders; if you are going to do any or all these things you will need a bureaucracy.

Such a bureaucracy consists of armed forces, police forces and a civil service. These are largely autonomous bodies. Theoretically they are subordinate to a democratically elected Parliament, but the Army, Navy, and Air Forces are controlled by specially trained officers who from their schooldays onwards are brought up in a narrow caste tradi-

tion, and who always, in dealing with Parliament, can dominate that body by their superior technical knowledge, professional secrecy, and strategic bluff. As for the bureaucracy proper, the Civil Service, anyone who has had any experience of its inner workings knows the extent to which it controls the Cabinet, and through the Cabinet, Parliament itself. We are really ruled by a secret shadow cabinet, the heads of the Treasury, the Foreign Office, the Home Office, the Service Departments, and the Permanent Secretary to the Cabinet. Below this select club of Old Wykehamists we have a corps of willing and efficient slaves—beetle-like figures in striped trousers, black coats, winged collars, and bow ties. All these worthy servants of the State are completely out of touch with the normal life of the nation: they are ignorant of the methods and conditions of industrial production, unaware of the routine and atmosphere of proletarian life—or life of any real kind.

Every country has the bureaucracy it deserves. Ours, trained in public school and university, is efficient, unimaginative, unfeeling, dull, and honest. In other countries the bureaucracy has no such gentlemanly traditions; it is lazy, lousy, and corrupt. In any case, lazy or efficient, honest or corrupt, a bureaucracy has nothing in common with the people; it is a parasitic body, and has to be maintained by taxation and extortion. Once established (as it has been established for half a century in

England and as it is newly established in Russia) it will do everything in its power to consolidate its position and maintain its power. Even if you abolish all other classes and distinctions and retain a bureaucracy you are still far from the classless society, for the bureaucracy is itself the nucleus of a class whose interests are totally opposed to the people it supposedly serves.

As an example of the power and selfish interest of the bureaucracy, consider the fate of the League of Nations. It is commonly assumed that the League was frustrated first by Japan and then by Italy, and that France and England refused to enforce its authority on these test occasions because they were not sufficiently armed to fight. Such may have been the actual catastrophe, but the ground had been slowly and deliberately undermined. The League of Nations was destroyed by a rival League —the League of Diplomats. Ambassadors and secretaries the world over saw in the League of Nations a rival organization, which when perfected would reduce their embassies to post-offices and replace their several provinces by a single central authority. So on every possible occasion the permanent officials of every Foreign Office in Europe did all in their power to frustrate the activities of the League. They have been only too successful!

What we have to ask, then, is how can the bureaucracy be abolished in a communist State? If we cannot answer that question, we have to admit

that our ideal of a classless society can never be realized.

The syndicalist—the anarchist in his practical rather than his theoretical activity—proposes to liquidate the bureaucracy first by federal devolution. Thereby he destroys the idealistic concept of the State—that nationalistic and aggressive entity which has nearly ruined Western civilization. He next destroys the money monopoly and the superstitious structure of the gold standard, and substitutes a medium of exchange based on the productive capacity of the country—so many units of exchange for so many units of production. He then hands over to the syndicates all other administrative functions—fixing of prices, transport, and distribution, health, and education. In this manner the State begins to wither away! It is true that there will remain local questions affecting the immediate interests of individuals—questions of sanitation, for example; and the syndicates will elect a local council to deal with such questions—a council of workers. And on a higher plane there will be questions of co-operation and exchange between the various productive and distributive syndicates, which will have to be dealt with by a central council of delegates—but again the delegates will be workers. Until anarchism is complete there will be questions of foreign policy and defence, which again will be dealt with by delegated workers. But no whole-time officials, no bureaucrats, no politi-

cians, no dictators. Everywhere there will be cells of workers, working according to their abilities and receiving according to their needs.

I realize that there is nothing original in this outline of an anarchist community: it has all the elements of essential communism as imagined by Marx and Engels; it has much in common with Guild Socialism and Christian Socialism. It does not matter very much what we call our ultimate ideal. I call it anarchism because that word emphasizes, as no other, the central doctrine—the abolition of the State and the creation of a co-operative commonwealth. But against all these forms of socialism, challenging the possibility of this ultimate ideal, is the cry that it can never be established because of the natural depravity of mankind. Even if one non-governmental community could be established, it is said, some predatory tribe or nation would descend on it and annex it.

To that objection we must reply that anarchism naturally implies pacifism. I would therefore propose to avoid that issue for the moment. I do not shirk the question: I shall discuss it more fully in the next chapter.

The objections raised by the state socialist (he now usually calls himself a communist) are based on grounds of practicability. Modern existence, he says, has become so immensely complicated that it cannot be simplified now without causing great suffering and chaotic disorganization. Apart from

retorting that no disorganization or suffering could conceivably be greater than that caused by the collectivization of agriculture in Russia, the answer to this charge must be that it is precisely the charge which has been brought against every attempt to reform the social system. When the communists object to the anarchists on grounds of impracticability, unreality, idealism, and so on, they are merely repeating, at an interval of thirty or forty years, the arguments used against themselves by the reactionaries of the past.

What matters in politics—what matters in history—is clarity of vision, force of reason. Nothing, in the slow course of civilization, has ever been won by any other means. A man has contemplated existence; has seen its elements clearly and discretely; has seen how these elements could be re-arranged to better effect, to greater well-being. In that way—entirely realistically—a vision is born, and a man who has seen this vision has shown it to his friends and neighbours, who have then become inspired with the same vision. And so a group, a sect, a party has been formed, the necessary enthusiasm has been aroused, and the vision has in due time been realized. That is the only way in which progress takes place—the only way in which a civilization is built up. When there are no longer men who have such visions, then progress ceases and a civilization decays. Such is the essential law of history—a law to which the

theory of dialectical materialism is but a corollary.

It will be seen that there is nothing in this conception of anarchism to prevent the emergence of an aristocracy of the intellect. Anarchism is not in this respect an egalitarian doctrine, any more than communism is. The distinction is that anarchism would not confer any special powers upon such an *élite*. Power corrupts even the intellect, and an aristocracy plus power is no longer an aristocracy, but an oligarchy. The seer, the visionary, the poet will be respected and honoured as never before in the history of mankind; but that dreadful confusion between the man of imagination and the man of action will be avoided. Imagination renders a man incapable of determinate action; determinate action inhibits imagination—such is the dialectic of the human personality.

Anarchism is a rational ideal—an ideal common to Marx, Bakunin, and Lenin. It is only because that ideal has been lost sight of in the collective socialism of contemporary Russia that it becomes necessary to reaffirm it under its most uncompromising name. Socialism is dynamic: it is a movement of society in a definite direction and it is the direction that matters most. In our conception of socialism, are we moving towards centralization, concentration, depersonalization; or are we moving towards individualization, independence, and freedom? It seems to me that there can be no possible doubt as to which direction is the more

89

desirable; and I am afraid that, at the moment, everywhere in the world except perhaps in Spain and China, we are moving in the wrong direction.

It is often said, by advocates of fascism and the totalitarian state, that democracy has failed because the electorate has proved unworthy of the responsibility which that system of government places upon it. At election times it acts either capriciously or ignorantly, or even refuses to act at all. This observation is based on certain true facts: it is the deduction only which is wrong. Even in my own lifetime, I am conscious of a great slackening of political consciousness. Politics do not occupy the space they used to in the press, and parliamentary proceedings are no longer followed with any great interest. For the most part, though their fate may depend on the result of their voting, the electors are bored and apathetic. Even with all the machinery of party organizations, publicity campaigns, door-to-door canvassing, open-air meetings, broadcasting, etc., it is difficult to get more than 50 per cent of the electorate into the polling booths. Without these artificial stimulants, it is doubtful if as much as 30 per cent of the electorate would exercise the right to vote.

But the reason for this apathy is not strictly political. It may be a case of democracy not functioning, but you cannot blame a vehicle for not moving if you overload it. The degeneration of

political consciousness in modern democratic states is not a moral degeneration. It is due to this very process of centralization and collectivization which is taking place independently, and in spite of the particular political system we supposedly enjoy. There was a time when the relationship between the citizen and his representative in Parliament was direct and human; there was a time when the relationship between a member of Parliament and the government was direct and human; but all that has passed. We have been the victims of a process of dehumanization in our political life. Parties have become obedient regiments of mercenaries; delegates have been replaced by committees; the paid official, the omnipresent bureaucrat, stands between the citizen and his Parliament. Most departments of national life are controlled by vast and efficient bureaucratic machines which would continue to function to a large extent independently— that is to say, irrespective of political control.

Universal political franchise has been a failure— that we have to confess. Only a minority of the people is politically conscious, and the remainder only exist to have their ignorance and apathy exploited by an unscrupulous press. But do not let us confuse universal franchise, which is a system of election, with democracy, which is a principle of social organization. Universal franchise is no more essential to democracy than divine right is to monarchy. It is a myth: a quite illusory delegation

91

of power. Justice, equality, and freedom—these are the true principles of democracy, and it is possible —it has been amply proved by events in Italy and Germany—that the universal franchise can in no sense guarantee these principles, and may, indeed, impose a fiction of consent where in effect no liberty of choice exists.

If you go into a village and propose to introduce electric power; if you go into a city street and propose to widen it; if you raise the price of bread or curtail the hours of drinking licences—then you touch the immediate interests of the citizen. Put these questions to the voter and without any coaxing or canvassing he will run to the poll.

In short, real politics are local politics. If we can make politics local, we can make them real. For this reason the universal vote should be restricted to the local unit of government, and this local government should control all the immediate interests of the citizen. Such interests as are not controlled by the local council should be controlled by his local branch of the syndicate or soviet to which he belongs. His remoter interests—questions of co-operation, intercommunication, and foreign affairs—should be settled by councils of delegates elected by the local councils and the syndicates. Only in that way shall we ever get a democracy of vital articulation and efficient force.

It is important, however, to make one qualification without which any democratic system will fail. A de-

legate should always be an *ad hoc* delegate. Once a delegate separates himself from his natural productive function, once he becomes a *professional* delegate, then all the old trouble sets in again. The bureaucratic parasite is born; the evil principle of leadership intervenes; the lust for power begins to corrode these chosen people. They are consumed by pride.

The professional politician is an anomalous figure, and should some day be subjected to a thorough critical analysis. The professional economist is one thing—he is an expert in one department of knowledge and should be capable of supplying a specific need in the community. The local man of standing—a landowner or active industrialist who allows himself to be elected to Parliament from a sense of responsibility and duty —he too is a justifiable type. But there exists this other type of politician who has no such functional status. He is the man who deliberately adopts politics as a career. He may incidentally be a lawyer or a trade-union secretary or a journalist; but he is in politics for what he can get out of it. He means to climb to office and to power, and his motive throughout is personal ambition and megalomania. Owing to the preoccupations of the other types of parliamentary representatives, this professional politician is only too likely to succeed. It is he in particular who is a danger in a socialist society, for with the disappearance of the disinterested man of leisure, he becomes the predominant type of poli-

tician. Unchecked by rival types, he monopolizes all offices of power, and then, intoxicated with the exercise of this power, turns against his rivals within his own category, ruthlessly exterminates those who threaten to supplant him, and enforces the strict obedience of all who promise to serve him. Such is the process by which dictators rise and establish themselves; such is the process by which Mussolini, Stalin, and Hitler have established themselves. It is a process which the social democratic State unconsciously but inevitably encourages. The only safeguard against such a process is the abolition of the professional politician as such and the return to a functional basis of representation. It ought to be axiomatic in a communist society that power is never delegated to an individual as such, to be exercised arbitrarily. Power should be an abstraction, a grace invested in an office, exercised impersonally. An elected delegate or representative should never confuse his authority with his individuality—it is the old distinction which the Church made between the divine grace and the human vessel.

Generally I would suggest that in many respects parliamentary socialism, which is the final expression of a subjective and individualistic doctrine of power which began its fatal course at the Renaissance, has to return to concepts of grace, freedom and function which are more in line with scholastic Christian philosophy than with modern philosophy.

I have always tended to see in communism a re-
affirmation of certain metaphysical doctrines which
Europe possessed in the Middle Ages, and then lost
in the rising tide of humanism, liberalism, and
idealism. I do not believe that we can go back to
the religious formulas of the Middle Ages, and for
that reason I do not believe that we can be saved
by a revival of Catholicism; in the theory of anar-
chism the organized Church is as much an anathema
as the State. But it is very necessary that we should
once again admit the universalism of truth and
submit our lives to the rule of reason. This univer-
salism and this reason, as Catholic philosophers
insist, are aspects of realism.[1] There can only be

[1]For a brilliant restatement of the Catholic doctrine, see
Professor Étienne Gilson's essay on 'Medieval Universalism and
its Present Value' in *Independence, Convergence and Borrowing in
Institutions, Thought and Art* (Harvard University Press, 1937)
Here are a few sentences which give the gist of his conclusions:
' . . . mental liberty consists in a complete liberation from our
personal prejudices and in our complete submission to reality
. . , Either we shall be free from things, and slaves to our minds,
or free from our minds because submitted to things. Realism
always was and still remains the source of our personal liberty.
Let us add that, for the same reason, it remains the only guaran-
tee of our social liberty. . . . Our only hope is therefore in a widely
spread revival of the Greek and medieval principle, that truth,
morality, social justice, and beauty are necessary and universal
in their own right. Should philosophers, scientists, artists, make
up their minds to teach that principle and if necessary to preach
it in time and out of time, it would become known again that
there is a spiritual order of realities whose absolute right it is to
judge even the State, *and eventually to free us from its oppression*
. . . In the conviction that there is nothing in the world above uni-
versal truth lies the very root of intellectual and social liberty.'

one kind of truth because there is only the single reality of our experience, and we arrive at the true nature of that experience by the process of reasoning. As communists we speak of our dialectical materialism, but we mean our dialectical realism. The negation of the idealism of Hegel is realism: the realism of Aristotle, of Albertus and Aquinas; the realism of the empirical tradition in modern science.

When we follow reason, then, in the medieval sense, we listen to the voice of God: we discover God's order, which is the Kingdom of Heaven. Otherwise there are only the subjective prejudices of individuals, and these prejudices inflated to the dimensions of nationalism, mysticism, megalomania, and fascism. A realistic rationalism rises above all these diseases of the spirit and establishes a universal order of thought, which is a necessary order of thought because it is the order of the real world; and because it is necessary and real, it is not man-imposed, but natural; and each man finding this order finds his freedom.

Modern anarchism is a reaffirmation of this natural freedom, of this direct communion with universal truth. Anarchism rejects the man-made systems of government, which are instruments of individual and class tyranny; it seeks to recover the system of nature, of man living in accordance with the universal truth of reality. It denies the rule of kings and castes, of churches and parlia-

ments, to affirm the rule of reason, which is the rule of God.

The rule of reason—to live according to natural laws—this is also the release of the imagination. We have two possibilities: to discover truth, and to create beauty. We make a profound mistake if we confuse these two activities, attempting to discover beauty and to create truth. If we attempt to create truth, we can only do so by imposing on our fellow men an arbitrary and idealistic system which has no relation to reality; and if we attempt to discover beauty we look for it where it cannot be found—in reason, in logic, in experience. Truth is in reality, in the visible and tangible world of sensation; but beauty is in unreality, in the subtle and unconscious world of the imagination. If we confuse these two worlds of reality and imagination, then we breed not only national pride and religious fanaticism, but equally false philosophies and the dead art of the academies. We must surrender our minds to universal truth, but our imagination is free to dream; is as free as the dream; is the dream.

I balance anarchism with surrealism, reason with romanticism, the understanding with the imagination, function with freedom. Happiness, peace, contentment—these are all one and are due to the perfection of this balance. We may speak of these things in dialectical terms—terms of contradiction,

negation, and synthesis—the meaning is the same. The world's unhappiness is caused by men who incline so much in one direction that they upset this balance, destroy this synthesis. The very delicacy and subtlety of the equilibrium is of its essence; for joy is only promised to those who strive to achieve it, and who, having achieved it, hold it lightly poised.

VI

THE PREREQUISITE OF PEACE

My approach to this problem must again be personal. It may be that there is an abstract ethical question, and that the answer is unequivocally in favour of universal peace. It may be that there is a concrete biological question, and that the answer is unequivocally in favour of periodic wars. I doubt very much whether all the answers to all the questions that can be raised on this issue can be unanimous. There is not only a conflict of values involved, but also a hopeless confusion of motives. Some of the most aggressive and egotistical people I know are active pacifists; some of the gentlest and most sensitive men I have ever met were professional soldiers. They, too, hated war; but they accepted it.

I do not accept war. I consider that it is an insult to the life of reason, and that it is cruel and senseless and wholly evil in its effects. If its economic and social consequences I do not pro-

pose to speak—it is surely obvious enough to all who have lived in the post-war epoch that these have been disastrous. I seem to remember that Mr. Douglas Jerrold, one of our ablest apologists for war, once maintained that the Great War had been worth while because it had achieved the westernization of Turkey; but most of us find it hard to believe that the abolition of the harem and the fez was worth the sacrifice of twelve million lives.

In my opinion the most convincing arguments for war are not logical at all, but based on certain obscure psychological motives. I do not mean that the arguments are convincing because they are obscure (not an unknown state of affairs): I mean that certain rationalizations of war persist because they are the expression of an emotional energy which would otherwise be repressed. When these rationalizations take a definite and elaborate form, the process of sublimation is obvious enough to anyone with a psychological training. But it is more difficult to explain a far more general attitude towards war and peace, which is not active opposition or defence, but uncertainty or apathy. There may be two hundred thousand pacifists; there are a few hundred active militarists; but the very people who will be decimated in the next war remain in the mass indifferent to the fate that threatens them.

My own case, which is one of doubt rather than apathy, is perhaps typical enough. I belong to the

generation which did the fighting in the last war and I hated it from the minute it began until the end. When the war broke out, I was completely unmoved by the general enthusiasm for the Allied cause, and could have had no enthusiasm for war in any cause. The war seemed to me to be just a meaningless interruption in the great struggle for social justice. I was annoyed that my thoughts should be diverted from what I considered the real problems of life, and was full of impotent rage when I found that all my time and bodily activities were involved in that madness. But like most people in 1914 (for I had read *The Great Illusion*) I did not believe that the war could last for many weeks and after an interlude of training and camping, I expected that I should be able to return to my books.

But the war did not end so soon. It drifted on, and I with it. I was given a commission and drafted to a battalion of infantry, and in due course went to France and had the normal experience of a front-line infantry officer. I do not wish to disguise the fact that in some ways I gained from that experience. In England, in a battalion officered mainly by masters and senior boys from Eton, I had been made to feel my place—an inferior one. In France, in face of the common danger, I found that I had as much courage and endurance as most men, and more than some of the heroes of the playing-fields of Eton. That was a valuable discovery. But other-

wise the experience was for me one of overwhelming horror, and in 1919 I left the Army a more convinced pacifist than ever—a pacifist who could speak of the horrors of war with the authority of experience.

What was to be done about it? As writing was to be my business in life, I felt I must first write about this experience of war—tell the truth about it with calmness and detachment. But I found, much to my surprise, that no one wanted to know the truth about war. People were either sick to death of the subject and wanted to find a mental refuge in peace-time activities, or they wanted to boost our so-called victory. I published, at my own expense, some realistic poems under the title *Naked Warriors*, but although they were well reviewed, not more than 300 or 400 copies were sold. I wrote an account of the Retreat of March 1918, and though (or because!) I made it as objective as possible, and kept it quite free from propaganda of any kind, I could not find a publisher for it—it was not published until five years later. This was all very discouraging, and though I have since written one or two other descriptions of war incidents, I feel that this method is not effective, and that, in short, the more effectively war is represented *as literature*, the more attractive war itself becomes. It is obvious that its horrors fascinate people (even women), and it sometimes seems that if one wants to prevent war, it is better to act as if it had never existed.

102

The self-confidence which is one of the positive values gained by the personality in war may possibly come in the course of an active life in peace time, though not, I think, so quickly. I do not for a moment entertain the idea that it is worth the sacrifice of life exacted by modern warfare. But the effects of war on the individual go deeper. I can only hint at some of the obscurer manifestations of its influence. For example, it developed my sensibility in such a way that I know instinctively which among the people I meet are cowards. Not merely which *were* cowards in the war, but which would be cowards in any position of danger. It is not a very comforting knowledge to have of one's fellow men; and certainly it does not add to one's social complacency, for under the present economic dispensation it is certain that the coward often rises to a place of authority and power. But it is reasonable to believe that in the long run courage adds to the sum total of human happiness, and if war sharpens our sensibility to this element in life, it awakens in us the desire to cultivate it.

Such a peculiar sensibility could not be developed in any conditions but those of prolonged common danger. It may be that there are certain peace-time callings, such as coal-mining, which develop the same qualities, but these only affect a small minority of the population. I am not sure that the same is not true of that other quality which war develops so conspicuously—comradeship. The pacifists them-

selves are so conscious of this virtue in war, that they propose to establish all kinds of group activities to inculcate it under peaceful conditions. They even, to a large extent, set out to imitate the organization and training of the military machine.[1]

Comradeship is a group feeling, and apart from its sentimental associations, we may assume that its value, like courage, is of a biological nature. It is the little man's defensive gesture in the face of the cold comfort of the material world. But however many of these biological virtues we may find in war, their value is obviously relative to the evil which is called into existence by the same circumstances. No amount of courage and comradeship will avail us if in the end all our brave men are exterminated and our civilization is destroyed. We must ask ourselves whether the virtues which arise from modern warfare are biologically of more value than the corresponding vices. "Tis strange to imagine that *War*', wrote Shaftesbury in his *Characteristics*, 'which of all things appears the most savage, shou'd be the Passion of the most heroick Spirits. But 'tis in War that the Knot of Fellowship is closest drawn. 'Tis in War that mutual Succour is most given, mutual Danger run, and *common Affection* most exerted and employ'd. For *Heroism* and *Philanthropy* are almost one and the same. Yet by a small mis-

[1] See *Training for Peace: a Programme for Peaceworkers*, by Richard B. Gregg.

104

guidance of the Affection, a Lover of Mankind becomes a Ravager: A Hero and Deliverer becomes an Oppressor and Destroyer.'

On examination, it will be found that the biological case for war rests on a certain apotheosis of 'Life' or 'Nature' which has no reasonable sanction. It is a great error in philosophy (to my way of thinking) to ascribe independent existence and overriding authority to creations of the mind or imagination. The process of evolution, so far as the scientists have been able to reconstruct it, seems to have been anything but certain and determinate in its course; and though by acquiring consciousness the human race has been able to nurse an illusion of controlling its own destiny, the very question we are discussing shows how ineffective that control has been. The only certain purpose of life is the process of living; the only awareness of this process is the individual consciousness; and since war destroys the individual life, it would seem to be biologically indefensible save when the only means of securing a living is to take another's life. But though the economic causes of war are evident enough, few apologists for war resort to this argument. It is too obvious that with modern methods of production there is potentially enough for everybody's need. What then remains of the biological argument?

It is worth recalling the work of a French writer whose influence, though not often acknowledged, is

105

still active among the few who openly defend war. René Quinton, who died in 1925, was a French biologist who took a distinguished part in the Great War. When war broke out he was already in his forty-eighth year, and though an officer of the reserve, no longer liable for active service, he volunteered and served continuously with the artillery. He was wounded eight times, received high Belgian, British, and American decorations as well as the French Croix de Guerre, and was appointed successively Officer and Commander of the French Legion of Honour. After the war Quinton returned to his scientific work, and only in 1924 began to put together the maxims which were subsequently published in book form. He did not live to see the publication of this book.

Mr. Douglas Jerrold wrote a long introduction to the English translation of Quinton's book,[1] presenting his maxims as a coherent philosophy of war, a philosophy which he has since developed in his own writings. Maxims are a very elusive type of literature, and the maxim-writer is always more concerned for the truth of his particular observation than for their consistency one with another. Many of these maxims are direct observations from experience, and strike us immediately as acute. This distinction between brave men and heroes, for example: 'The brave man gives his life when it is asked of him; the hero offers it.' 'The hero is a

[1] *Soldier's Testament*. (Eyre & Spottiswoode, 1930.)

106

mystic and perhaps it takes a hero to understand him.' 'Courage comes from the exact computation of probabilities.' 'Bravery is an intellectual rather than a moral quality.' 'There is no discipline in the firing-line; there is mutual consent. Discipline begins behind the line.' In such maxims the soldier is speaking, but in the majority of them it is an elderly biologist. Mr. Jerrold says: 'The keystone of Quinton's thesis is the doctrine that the end of life, for the male, is something beyond life, and that until this instinct to serve the race, or, more widely, the universal purpose behind life, is dominant, man is not truly masculine, not truly mature. Pacifism and malthusianism alike are regarded as definitely unnatural, an attempt to defy, with results ultimately disastrous, the fundamental biological instincts of the female and the male.' And again: 'An idea for which a man is not prepared to die is not an idea sufficiently dynamic to stimulate the instinct to serve, and it is on the stimulation of this instinct, on its predominance over all else that, as a matter of mere biological necessity, the health of the race depends. For it is only in serving that the male can attain moral dignity, without which the race must deteriorate and ultimately decay.'

The fallacy on which this doctrine is based is derived from the romantic biologists of the last century; it is a version of the pathetic fallacy which takes the form of a personification of an imaginary

force called Nature. 'It is the intention of *Nature*,' reads Quinton's first maxim, 'that man should die in his prime.' '*Nature* creates species, she does not create individuals,' runs the second. And so on, throughout the whole book, we have this unconscious assumption, and if the reader does not care to accept it, the philosophy of war based on it falls to the ground.

Hitherto I have referred to pacifists generally, but actually there are two schools of thought among the opponents of war. One is humanitarian, maintaining the dignity and sanctity of life, regarding war as a barbaric survival; the object of life, one must suppose, is more life, and a better life. These are the pacifists proper, and their doctrine rests on practically the same assumption as René Quinton's—a conception of Man as part of a purposive life-force. Another doctrine, which Mr. Jerrold confuses with this, has no such sentimental bias. 'Life' may be purposive or not; it is beside the point. But 'life' cannot be reduced to a single concept. There are different kinds of life—mineral, vegetable, animal, and human. Human life is distinguished by the possession of unique faculties which we commonly call reason. In the hierarchy of life, reason involves a difference, not of degree only, but of kind; so that no proposition that is true for the life of instinct is necessarily true for the life of reason. But reason, not being prejudiced, can admit the insecurity of its tenure; it is for ever

challenged by the ineradicable passions which we inherit with our animal frame. It must therefore defend itself, and in that defence it must be willing to sacrifice life. Only those who unconsciously prefer death (and call their preference 'non-attachment') are unwilling to sacrifice life. The rational opponent of war, it follows, is not a pacifist, for he believes that there are ideals for which in the last resort he must wage war. But as part of his fight against his own instincts, he will fight against the instinct to fight. He knows that that instinct is a mark of decadence, for wars mean economic waste, racial debility, and intellectual poverty. Mr. Jerrold seems to accept Spengler's theory of history, and no doubt some such fatalism is necessary if you are to justify war. But it is far more reasonable to suppose that civilizations have perished from too much war rather than from too little of it. This is the view expressed by George Santayana in his book *Reason in Society*:

'Internecine war, foreign and civil, brought about the greatest set-back which the life of reason has ever suffered; it exterminated the Greek and Italian aristocracies. Instead of being descended from heroes, modern nations are descended from slaves; and it is not their bodies only that show it. After a long peace, if the conditions of life are propitious, we observe a people's energies bursting their barriers; they become aggressive on the strength they have stored up in their remote and

109

unchecked development. It is the unmutilated race, fresh from the struggle with nature (in which the best survive, while in war it is often the best that perish), that descends victoriously into the arena of nations and conquers disciplined armies at the first blow, becomes the military aristocracy of the next epoch and is itself ultimately sapped and decimated by luxury and battle, and merged at last into the ignoble conglomerate beneath. Then, perhaps, in some other virgin country a genuine humanity is again found, capable of victory because unbled by war. To call war the soil of courage and virtue is like calling debauchery the soil of love.'

This conception of war agrees with the record of history and is not dependent on any fanciful apotheosis of the life-force. It also emphasizes the fact that it is not necessary to be military to be masculine. All the virtues that are necessary for the preservation of a civilization are naturally evolved in the process of building up that civilization. It requires far more courage to preserve a civilization than to destroy it. The life of reason is itself a sufficient safeguard against decadence.

Another curious confusion arises out of Mr. Jerrold's misunderstanding of the rational pacifist's position. He says, in effect, that the rationalist cannot believe in any absolute values because the only effective way of believing in such values is to establish them by force. But reason achieves its end by persuasion. Force is only necessary to establish

110

irrational values. If the word 'absolute' has any meaning in this connection, it implies a quality that is universal. It is inconceivable, therefore, that nation should fight against nation for the establishment of universal values. If such values exist, they will be obvious to all men of reason; and if it is necessary to establish them by force, they will be supported by men of reason irrespective of race or country. A war in that sense is a crusade, and a crusade is the only kind of war which a reasonable man might countenance.

Both fascism and marxism claim to be crusades in this sense, but the very fact that these doctrines claim to be universal and yet oppose each other shows that they cannot both be based on reason. Either one or both must be invalid as a crusade. It is almost inconceivable that a truth should be so universally accepted by men of reason that it would justify a crusade to establish it. War in practice is always an attempt to circumvent the process of reasoning, which is slow and difficult. Fighting and reasoning are different means to the same end, and if we assume that the life of reason is an absolute value and war merely a means sanctioned by the values it aims to establish, and not in itself an absolute value, then we must agree with Santayana that the only rational war is a war to end war. The only valid crusade is a crusade to establish universal peace.

At first sight, this conclusion would seem to
111

justify those who argue that if we would ensure
peace we must prepare for war: that peace can only
be guaranteed by force of arms. Such a position
ignores, as pacifists have often pointed out, the
positive evils of a state of war-mindedness. You
cannot sit on a powder-magazine and smoke your
pipe in peace. Sooner or later a spark sets fire to
it. If peace can only be guaranteed by force then
that force must be super-national. But by the time
we have arrived at a political and economic
organization of the world which will allow the
creation of such a force, we shall have arrived at
a state of civilization which will render such a
force unnecessary.

I will leave these well-worn and irrefutable argu-
ments on one side to consider a more difficult
aspect of the problem. Some time ago the League
of Nations sponsored the publication of a discussion
on our subject by two of the greatest scientists of
our time—Albert Einstein and Sigmund Freud.[1]
Einstein puts forward the point we have just been
considering; he realizes that the practical solution
of the problem of war is superficially simple. 'The
quest of international security involves the uncon-
ditional surrender by every nation, in a certain
measure, of its liberty of action, its sovereignty,
that is to say, and it is clear beyond all doubt that
no other road can lead to such security'. But 'the

[1] *Why War?* By Albert Einstein and Sigmund Freud. (Allen &
Unwin, 1933.)

ill-success, despite their obvious sincerity, of all the efforts made during the last decade to reach this goal leaves us no room to doubt that strong psychological factors are at work, which paralyse these efforts'. Einstein therefore calls on Freud to bring the light of his 'far-reaching knowledge of man's instinctive life' to bear upon the problem.

Einstein asks his questions simply and modestly; Freud's answer is, it must be confessed, a little pretentious and evasive. He supposes the existence in man of two innate and opposite tendencies—the will to create and the will to destroy, Love and Hate, the polarities of attraction and repulsion which operate the whole of the vital, and perhaps of the physical universe. But he sees no simple or innocuous way of controlling the destructive instinct; he is led to the conclusion, rather, that this instinct is present in every living being, striving to work its ruin and reduce life to its primal state of inert matter. For that reason we might well call it the 'death instinct'. This death instinct becomes destructive when it directs its action outwards, against external objects. But sometimes it directs itself inwards, and Freud traces the origin of a number of normal and pathological phenomena to such an introversion of the destructive instinct. Obviously, he argues, when this internal tendency operates on too large a scale, a positively morbid condition arises; whereas the diversion of the destructive impulse towards the external world

must have beneficial effects on the individual. And such is the biological justification for the aggressive impulses in mankind. What is much more difficult to explain, says Freud, is why we should make a stand against these malicious but natural propensities.

There Freud, for the moment, leaves the question, and there Dr. Edward Glover, an English psycho-analyst, takes it up. He begins by quoting a passage from this letter of Freud's, and his short book,[1] which is of quite exceptional importance, is an attempt to trace the psychological complexities involved in the problem of war and peace. His thesis is, briefly, that there is a fundamental identity between some of the impulses promoting peace and the impulses giving rise to war, and that no effective peace propaganda will be possible until we realize this fact. When the destructive instinct is suppressed in man (it is usually frustrated in infancy), then we are liable to get psychological reactions of two kinds: sadistic when the destructive impulse is turned outwards and fused with the erotic impulse, masochistic when to some degree the destructive impulse is turned inward against the self. As applied to the problem of war and peace, Dr. Glover's thesis is briefly this: 'The psycho-analyst alleges that *concentration of peace propaganda on ethical or economic arguments*, on measures of inhibition, pacts, disarmament treaties or limita-

[1] *War, Sadism and Pacifism.* (Allen & Unwin, 1933.)

tions, to the neglect of unconscious motivations, *is in a very real sense a reactionary policy*. He alleges that *peace and war manifestations are both essentially end products, the results obtained by passing the same psychic energies through different mental systems*. Or to put it another way, that peace and war activities are both solutions of mental tension, the apparent and actual difference being due to the different defensive mechanisms employed. He states that *the driving energy in both cases belongs to the destructive group of instincts*, in particular that variety which when fused with some love components is known as sadism. And in illustration of this he points out that the fanatical pacifist under certain circumstances may be a danger to peace. He also points out, however, that in addition to this active form of destructive impulse an element of confusion is introduced by a passive form, namely masochism, in which destructive impulses are fused with passive love components. These *passive destructive impulses* are more silent in operation than the active sadistic components; nevertheless they *contribute considerably to an unconscious readiness to tolerate or even welcome situations of war*. And they do so not merely by paralysing the operation of self-preservative impulses, but because the acceptance of suffering, in addition to being a primary form of gratification, represents a primitive method of overcoming "unconscious guilt".'

This thesis has done much to discredit the

115

present methods of pacifist propaganda; moreover, it explains why some of us, who are pacifists in reason, have never been able to be pacifists in practice. We have been aware of the fact that most of our fellow-pacifists are actuated, not by rational motives, but by an obscure perversion of the very instinct which should be recognized and rationally controlled.

Dr. Glover has no ready alternative to propose, and admits that there is no agreement among psychologists—that there is, in fact, at present no scientific remedy for the evil of war. He confines himself to his diagnosis and calls for a more realistic inquiry. As a psycho-analyst he believes that the instincts giving rise to war are obscured in childhood; the foundations of peace reactions are laid in the same period. The remedy, presumably, is in the hands that rock the cradles all over the world. But how instil the right virtues into such hands? Dr. Glover does not know. Dr. Freud does not know. Nobody knows, and meanwhile war is threatening the very existence of our civilization.

Freud's theory of the destructive instinct is, of course, only an hypothesis; but to accept merely the general psychological notion of an instinct predisposing the mass of mankind to warlike activities is to admit the futility of all our present pacifist methods. To arm for peace, even internationally, is to ensure that plenty of weapons will be at the disposal of those instincts once they can no longer be

116

restrained. To adopt an attitude of non-resistance (Gregg, De Ligt, Aldous Huxley, and the Peace Pledge Union) is to assume that the obvious does not exist. It is particularly significant that Mr. Huxley, who is not innocent of psychology, should so completely ignore the psychological problem. He does, it is true, note Dr. J. D. Unwin's theory according to which the rise of war may be correlated with the increased sexual continence of an emergent ruling class; and freely admits what from my own point of view is an immediate symptom of war psychology—the rise of self-conscious leaders preoccupied with the ideas of personal domination and personal survival after death. But his general attitude is governed by his doctrine of non-attachment, which is in itself a typical product of the death instinct.

What then shall we do? We can undertake the research programme outlined by Dr. Glover, but its outcome is admittedly doubtful, and in any case it demands a period of experiment and educational training measured in centuries. Moreover, that programme can only be realized under conditions which are absolutely inconsistent with present systems of government and present economic structures. It involves, in fact, handing over the supreme power in each country to the modern equivalent of the philosopher-king—to the psychological expert. I think that most nations would rather perish than do that.

117

The only realistic approach, because the only approach which promises immediate and far-reaching changes in the structure of society, is the revolutionary approach. Economic imperialism is so demonstrably dependent on the support of armed force that only the most prejudiced capitalist can pretend to ignore its importance as a factor in the encouragement of latent warlike instincts. But the capitalist is quite logical (and for once he has the support of the psychologist) when he points out that warfare has a longer history than capitalism, and that the establishment of socialism in Russia, for example, has by no means been accompanied by a decline of the martial spirit. It may be argued that militarism in the U.S.S.R. is purely defensive; but it is militarism none the less, and there are few countries where the pacifist is less free to preach his doctrine of non-resistance. So long as nationalism persists as a sentiment, so long as collectivism masquerades as socialism, so long will socialist units be nothing more than militarist units magnified and intensified.

War increases in intensity and effect as society develops its central organization. The greatest intensification of the horrors of war is a direct result of the democratization of the State. So long as the army was a professional unit, the specialist function of a limited number of men, so long war remained a relatively harmless contest for power. But once it became everyman's duty to defend his

home (or his political 'rights') warfare was free to range wherever that home might be, and to attack every form of life and property associated with that home.

The economic foundations of peace will never be secure so long as collective units such as the nation exist. So long as it is possible to unite men in the name of an abstraction, war will exist; for the possibility of uniting the whole of mankind under the same abstraction is too remote to be worth considering, and as long as more than one abstraction exists with collective forces organized behind it, the possibility of war will exist.

The only pacifist peoples are certain so-called savage tribes living under a system of communal land tenure in a land of plenty: communities where the accumulation of capital and the power it gives has no purpose and therefore does not exist, and where there is no possibility of one man exploiting the labour of another. These conditions create, not only the social and economic possibilities of peace, but also the far more important psychological possibilities. Such communities are, in the precise meaning of the word, *anarchist* communities.

There is no problem to which, during the last twenty years, I have given more thought than this problem of war and peace; it has been an obsession with my generation. There is no problem which leads so inevitably to anarchism. Peace is anarchy. Government is force; force is repression, and repres-

119

sion leads to reaction, or to a psychosis of power which in its turn involves the individual in destruction and the nations in war. War will exist as long as the State exists. Only a non-governmental society can offer those economic, ethical and psychological conditions under which the emergence of a peaceful mentality is possible. We fight because we are too tightly swathed in bonds— because we live in a condition of economic slavery and of moral inhibition. Not until these bonds are loosed will the desire to create finally triumph over the desire to destroy. We must be at peace with ourselves before we can be at peace with one another.

THE IMPORTANCE OF LIVING

A modern Chinese philosopher, Lin Yutang, has recently published a book under this title. It is a book that expresses, as well as any I know, the outlook on life with which I most sympathize. It is not entirely my philosophy, because it is Oriental, and has many small incidental peculiarities which I do not share. It is also a philosophy with a tradition of many centuries of meditation behind it, and it has therefore a ripeness or maturity to which I cannot pretend. The tradition of the Western world is quite different, and anyone who revolts against it, as I do, must necessarily stand in isolation.

I am so imbued with the spirit of toleration—and toleration is an essential aspect of anarchism as I conceive it—that religion as such does not seem to me to enter into the discussion of public affairs. It is only when religion is organized and assumes dictatorial powers over the lives and conduct of everyone that I resent it. I resent the

government of the Church in the same way that I resent the government of the State. It is an intolerable interference with my liberty.

I cannot conceive religion as anything but the expression of individual emotions. I look around and see that some people 'profess' religion, others do not. I examine myself and find that I do not feel this religious need. I remember experiencing such a feeling in my youth, but it passed and left me serener and happier. I can only conclude that this feeling is the product of certain emotional stresses in the individual; and I am quite willing to admit that people who have these stresses are entitled to have the emotional or imaginative compensations which they need. But it is utterly fantastic to admit that they should have any right to impose their particular compensation on people who have no need of it.

But religion, it will be said, is far more than such a subjective fantasy: it is, for example, a system of ethics or an explanation of the universe.

Ethics is the science of good conduct. As such it implies a theory, or at least a sense, of values. But I fail to see how this sense can be imposed from above or from outside. The sense of right and wrong is a subjective sense: if I do not *feel* what is right and what is wrong, I cannot act rightly or wrongly, except under compulsion. To *know* a code of right and wrong is to know someone else's conception of right and wrong. Truth, justice, goodness, beauty

122

—these are the universals of the philosopher, and I have more than once assumed the reality of their existence. But when we try to define the mode of their existence, we are either reduced to dogmatic affirmations and the evidence of mystics, or are compelled to admit that there are only particular cases of truth, justice, goodness, and beauty. But to admit that truth, for example, is only the sum of particular truths at a particular time is to base all our speculations on a morass of relativism. That truth, single and invariable, does exist is the premiss of all science and philosophy. But is it not possible that the only truth is the law and structure of the universe, so far as we can observe it, and that all other truths are analogies derived from aspects of this physical order? Justice, for example, on this assumption, is an analogy of equal quantities; beauty is an analogy of symmetry and balance; goodness is perfect growth. With the Pythagoreans we can once more assert that the nature of all things is number. This would give the highest value to reason, which is the faculty by means of which we discover the laws of the universe and attempt to relate them to some general conception of its organization. Such a faculty, we may conclude, is well able to look after our morals.

The origin of conscience, and the knowledge of good and evil, can be explained within the terms of individual psychology. What is not within the scope of the subjective sense of good and evil—

certain wider aspects of social justice, for example
—is invariably a projection of this subjective
sense into the analogous body of the community. I
believe that we have acquired in the course of our
human history feelings of sympathy and mutuality
which compel us to subordinate our purely egoistic
impulses to the general good. Such feelings are often
most evident in simple uncivilized communities,
and most distorted or repressed in highly complex
civilizations.

As for our knowledge of the external world, in
so far as we can be certain of the objectivity of
such knowledge, I observe that it reveals a certain
structural harmony in the universe which is of
the greatest significance, and which we may, if we
have use for the symbol, identify with God. We
cannot yet and probably will never be able to grasp
the system of the universe in its completeness and
in its farthest ramifications. We have to confess
our ignorance and the limitations of our human
faculties. But the degree of our knowledge of the
universe is the guarantee of our liberty of action.
We can only act freely in a familiar environment.

It is tempting to identify our aesthetic emotions
with our awareness of the structural harmony of
the universe, but a closer examination of the
aesthetic creations of mankind shows that their
forms tend to depart in some degree from the
mathematical patterns which result from physical
laws. The emotion we experience when we perceive

the form of a crystal or of the solar system is not the same as the emotion we experience when we read Shakespeare's poetry or listen to Beethoven's music. This latter emotion is rather the thrill we experience from daring to depart from the patterns inherent in the universe. Art is thus an adventure into the unknown, and therefore purely subjective. This has not always been perceived, and a confusion has arisen between the imitation of universal patterns (the 'beauty' of classical art) and the creation of free patterns (which is art properly so-called).

Kierkegaard observes that we tend to experience the universe either aesthetically or ethically; and he supposed that these mutually exclusive attitudes could only be reconciled in a synthesis which is religion. But that seems to me to impose a totally unnecessary strain on the individual mind. The ethical and the aesthetic are but two aspects of the one reality—two methods of acquiring a knowledge of reality. Kierkegaard's third way to knowledge may exist, but it implies such an intense degree of subjectivity that it can only be cultivated by a minority of mystics.

From whatever angle we approach it life is thus an individual adventure. We enter the world as the world's most sensitive instrument. We are immediately subjected to thousands of sensations, some of them pleasant, some painful. By our nature we seek the pleasant, and though we soon discover

125

that the path of least resistance is not necessarily or finally the path of most pleasure, we endeavour to order our life so that it may contain the maximum intensity of pleasure. We become connoisseurs of the varieties of pleasure, and gradually evolve a hierarchy of pleasure which constitutes our culture. If that hierarchy is well built, our culture survives; if it is too selfish or too harmful to our health, our culture perishes.

Natural catastrophes—famine, disease, floods, storms, eclipses—these, before men could explain them rationally, inspired terror. The struggle for food inspired rivalry and hatred. The leader was the man who succeeded against all rivals, and he exploited not only his strength, but the terror which was latent in his fellow men. Lust for power and the fear of death are the original sins. They alone are sufficient to explain the repression of natural instincts and the creation of gloomy fantasies from which all the melancholy of the world proceeds. When we can cast out the fear of death and renounce any desire to dominate the least of our fellow men, then we can live in peace and happiness. And that is the final aim: neither to believe, nor suffer, nor renounce; but to accept, to enjoy, to realize the anarchy of life in the midst of the order of living.

THE
COMFORTING
ILLUSION

Lifting the Veil on
Organized Religion

GREG BENTALL

THE COMFORTING ILLUSION: LIFTING THE VEIL ON ORGANIZED RELIGION

1405 SW 6th Avenue • Ocala, Florida 34471 • Phone 352-622-1825 • Fax 352-622-1875
Website: www.atlantic-pub.com • Email: sales@atlantic-pub.com
SAN Number: 268-1250

Library of Congress Cataloging-in-Publication Data

Names: Bentall, Gregory, author.
Title: The comforting illusion / by Gregory Bentall.
Description: Ocala : Atlantic Publishing Group, Inc., 2019. | Includes bibliographical references.
Summary: "This book is a behind-the-scenes look at organized religion. It attempt to "lift the veil" so that the followers can understand how the whole religious enterprise works, and thereby use that information to make intelligent choices about their own, personal, spiritual journey. Religious practices have only the power that we give to them. Religion functions as a "comforting illusion," giving us a sense of security in a life full of perils"—Provided by publisher.
Identifiers: LCCN 2019023026 (print) | LCCN 2019023027 (ebook) | ISBN 9781620236529 (paperback) | ISBN 9781620236536 (ebook)
Subjects: LCSH: Religion.
Classification: LCC BL27 .B46 2019 (print) | LCC BL27 (ebook) | DDC 200—dc23
LC record available at https://lccn.loc.gov/2019023026
LC ebook record available at https://lccn.loc.gov/2019023027

Printed in the United States

PROJECT MANAGER AND EDITOR: Katie Cline
INTERIOR LAYOUT AND JACKET DESIGN: Nicole Sturk

Over the years, we have adopted a number of dogs from rescues and shelters. First there was Bear and after he passed, Ginger and Scout. Now, we have Kira, another rescue. They have brought immense joy and love not just into our lives, but into the lives of all who met them.

We want you to know a portion of the profits of this book will be donated in Bear, Ginger and Scout's memory to local animal shelters, parks, conservation organizations, and other individuals and nonprofit organizations in need of assistance.

— Douglas & Sherri Brown,
President & Vice-President of Atlantic Publishing

Table of Contents

INTRODUCTION

Behind the Curtain

The quest for faith is one of the strongest of all human urges. The oldest archeological sites on Earth show evidence of religious awareness that transcends time. The Neanderthals buried their dead, suggesting that they were aware of their own mortality.[1]

Human burial practices date back at least 100,000 years, when humans buried their dead below the ground so that the departed souls might dwell in the underworld.[2] As a part of the quest for faith, one is confronted with the following questions, and our answers determine our spiritual course:

- What happens when we die?

- How do we face the dangers and depravation in life?

- How do we deal with forces we cannot understand or control?

- What is the meaning of life? Are we here just to survive, to breed, and to die, or is there a higher purpose?

Religion is a human artifact designed to deal with those issues and questions. The answers to these questions of faith are beyond human comprehension, so we fill the gaps in our understanding with a comforting illusion. Somewhere along the line, humanity organized these illusions and called it religion. This religious illusion comforts us from an otherwise very harsh reality.

Believing an illusion is not a bad thing, however. The tooth fairy is not just random nonsense; it is an illusion we craft to soothe our children as they experience the potentially frightening event of losing their teeth. Because of the tooth fairy, children do not fear the loss of baby teeth, but rather see it as a chance for special attention and gifts.

My life and ministry have been anything but a straight line from point "A" to point "B" — I have had to reinvent myself multiple times. Following seminary, I was ordained as a pastor in what is now the Presbyterian Church (USA), the largest Presbyterian denomination in the United States. After several years of full-time pastoring, I went back to graduate school to earn my Master's in Business Administration (MBA). At that point, the church sought my services as a financial manager and regional church administrator, a role that took the next 14 years of my life and ministry. During this time as a regional church executive, I volunteered my pastoral services to a series of small congregations while also continuing my graduate-level theological education.

Eventually, due to a shift in mission-funding patterns across the church, financial managers at my level were no longer in high demand. I went to work as a financial manager for a series of social service agencies. During this time I also taught corporate finance to university students. After five years of financial hardships in the social service agencies, I decided that it was the time to move into the for-profit world and took a job as a financial analyst at a casino. I remained there for over 15 years before retiring as the Director of Finance.

I pledge to you that what I say in this book is said with absolute honesty. I will not polish my presentation of the illusion; I aim to lift the curtain so

that you may better understand its workings. As a pastor, I had to polish the illusion; that was my job at times. But here I do not have that constraint. Here, like a magician explaining a trick to his assistant, I will take you behind the illusion and show you what happens behind the smoke and mirrors. Like Dorothy in "The Wizard of Oz," I will lift the curtain and show you that the wizard is just an ordinary mortal equipped with fancy special effects and a mastery of illusions.

The purpose of this book is not to disparage religion but to illuminate the complexities that lie within the journey of faith and organized religion. Furthermore, while this book is written predominantly from a Christian perspective, I believe that there are ideas presented that can be universal and may be of great interest to those of other faith journeys, as well as for those skeptics who would reject the notion of religion in its entirety.

This book may be most helpful to those of a secular world view and to those who struggle with the paradox of living with a secular and religious viewpoint at the same time. Hyper-religious people often do not take kindly to those who disagree with them. In the past, you may have encountered those who think that your lack of faith somehow makes you "defective." During discussions with these religious people, you may have even been met with hostility: *You would not talk like that if only you were saved! You are just overtaken by sin and refuse to acknowledge it! The Godless are aimless!* Because of people and attacks like this, I, for one, am far more comfortable with skepticism than with the delusions of the ultra-religious.

It is exceedingly difficult for those with secular world views to participate in a culture that is organized according to religious illusion. You should be free to be an open and unabashed atheist without fear of rejection or reprisal, but this is unlikely in a country as steeped in religious tradition as America. According to The Huffington Post, as of January 2019 there were no declared atheists in Congress.[3] This number hardly seems representative as nearly one-quarter of the adult U.S. population call themselves atheist or unaffiliated.[4] Evidently, there are at least a few hidden atheists or agnostics in Congress who are unable to "come out of the closet" for fear of political retribution.

This book will not attempt to answer the question of whether or not God exists. That is far too big of a question to ever be answered. For the purposes of this book, I will assume that God exists, but it is not the same God as most people believe in.

There are many scientists, like Richard Dawkins[5] and Lawrence Krauss,[6] who will insist that there is no god. However, when they say "there is no god," what I believe they mean is that they are able to explain their view of the universe without invoking a god. Dawkins even wrote a book entitled "The God Delusion." If I could meet with Dawkins, I would say to him that if an observer were to look at a star through visible light alone, they might conclude that they've seen everything that there is to see of this star. But alternate wavelengths like infrared, ultraviolet, radio, and X-rays are unobservable with the naked eye, yet provide a totally different picture of the star. So really, my message to Dawkins and Krauss would be that they cannot ever be entirely certain that they're observing the whole picture. Seeing the whole picture involves using multiple tools, techniques, lenses, and methods. The only slight problem with this imagined discussion is that Dawkins is an evolutionary biologist and not an astronomer.

Faith and science are not necessarily incompatible, however. A number of scientists throughout history have been members of the clergy — Georges Lemaître was a 20th century Catholic priest who was instrumental in formulating the Big Bang theory,[7] and Gregor Mendel, the father of genetics, was an Augustinian Friar.[8]

Nature is full of seeming contradictions. Light is both a wave and a particle — the more one thinks about this paradox the more ridiculous it becomes. The state of the universe can be explained by general relativity and quantum mechanics; general relativity deals with large structures and forces in the universe, such as stars and galaxies, while quantum mechanics deals with the universe on a sub-atomic level. Both theories are well-founded and give extraordinary insight and predictive results. The only problem is that general relativity and quantum mechanics are radically incompatible with each other. Such is the seemingly contradictory, yet dualistically compatible theory of agnosticism. Agnostics, those who believe that we cannot

know for sure whether God exists or not, are an interesting breed capable of dualistic thought. Where the atheist says that the notion of God is an either/or proposition, the agnostic sees this as a both/and proposition. The agnostic has no trouble understanding light as a wave *and* a particle, or the universe being governed by general relativity *and* quantum mechanics. In the same way, the universe can be simultaneously created *and* uncreated. Atheists, however, would describe agnostics simply as atheists who lack the courage of their convictions.

My intent with this book is to further develop the notion that a personal faith journey involves embracing a comforting illusion that makes life more secure and less stressful. In fairness, this can be a great asset to the faithful so long as they understand that it is an illusion. But for some of those who fail to understand this concept, their journey of faith can become a delusion with many negative consequences; it can lead to religious extremism, discord, bigotry, hatred, and in the most extreme cases, it can lead to violence and terrorism. When a religious fanatic believes that their religious ideals are the only true reality, their walk of faith becomes a war waged against all who do not follow the same path.

There are many great and wonderful things to be said about a religious life. A religious community can be a great source of support and comfort as well as a base for coordinated group action. Participation in a community of faith is much like being a part of a large family. Even for someone who has just moved to a new town with no acquaintances, a faith community can quickly become an essential part of the newcomer's social life and circle of friends. Looking over the history of religious involvement, one can find countless acts of altruism through which people of faith made great sacrifices to care for others. There have been countless acts of justice and compassion, as well. Throughout the ages, the Church has established innumerable hospitals, orphanages, and soup kitchens. The Church has also often been at the forefront of social movements like abolition, temperance, suffrage, civil rights, and environmental conservation. It's important to remember that none of these things would have been possible without the dedicated work and financial support of the Church's people of faith. But religion is also a very potent drug that can be harmful if taken in the

wrong dose or in the wrong circumstances. While religion has the potential to unite people into thriving communities of faith, it can also divide us into warring tribes. One only needs to look at the centuries of warfare and persecutions in Europe following the Protestant Reformation and the crusades, or the ongoing violence between Sunni and Shia Muslims. It cannot be overlooked that while religious doctrine can preach and invoke justice and mercy, it can also incite violence and oppression.

The Church has founded and maintained great libraries and universities throughout the ages and with these institutions, played an extraordinary role in the collection, maintenance, and transmittal of knowledge from one generation to the next. Before the invention of the printing press, knowledge was passed down from generation to generation by monks who carefully copied informative texts so as to preserve the ancient knowledge. But the Church has also suppressed intellectual discoveries when those advancements did not align with the Church's ideologies. In 1632, Galileo was placed under house arrest and forced to recant his discoveries supporting the Copernican view that the Earth revolved around the Sun.[9] This same battle has waged on into the 19th and 20th centuries with Charles Darwin's theories on evolution. Sadly, this battle against the concept of evolution has somehow continued on even into the 21st century. It took 359 years for the Catholic Church to officially admit that Galileo was right,[10] and it could very easily take just as long for Darwinism to become universally and ecclesiastically accepted.

While religion can support great acts of altruism, it can also devolve into fanaticism, obstruction, and oppression of those with whom it disagrees. Religious supremacy has always been a very real problem and continues to be so in the current age. Religious supremacy states that the individual believes in their God and what that God represents, so to oppose those beliefs is to oppose the "true" God and the "correct" ideology. The rule of etiquette stating that one should never discuss religion or politics refers to the fact that religion, like politics, is often a source of division and strife. And therein lies the irony of religion in society; where it is meant to unite the people, it more often tears them apart.

So if you come away from this book with any message, I hope it is this: pursue the faith journey, or lack thereof, that is meant for you individually, and grant others the freedom to do the same. Though it can be easy to do, do not fall into extremism, fanaticism, bigotry, hatred, or religious aggression. If our society wishes to learn from and advance beyond our mistakes of the past, we must resist the temptation to force our personal religious beliefs upon others and coexist.

This book will very likely be difficult for many readers as it challenges the status quo and presents a very different perspective on many issues of faith than they may be used to being confronted with. This is particularly true for practicing Christians. I would encourage the faithful reader to push through the difficult passages and truly contemplate the issues raised, even if it causes them to wrestle with their own predilections. The issues raised herein are essential to the century in which we live and will need to be considered by even the most conservative of churches, pastors, and believers. We live in an increasingly secular world in which church participation is on the decline. America is following Europe into a post-Christian era, and we need to be prepared. If the Church fails to assimilate to the age in which we live, it will become ever more irrelevant to its few remaining followers in the modern world.

CHAPTER 1

The God Paradox

On May 22, 2011, a devastating tornado left the town of Joplin, Missouri in a shambles. There were 162 dead and 1,150 people injured. Property damage exceeded $2.8 billion.[11] St. Mary's Catholic Church was in splinters.[12] Imagine being the priest and having to explain this tragedy to the congregation. When asked if God could have prevented the tornado, the priest might say that of course God could have — God can do anything. Then he could be asked why God had chosen not prevent it. The priest might say that God is a mystery, and that mere mortals often cannot understand His ways. He might suggest that God would use this tragedy somehow for good. The more the priest might struggle to explain the conundrum, the more twisted and awkward his logic would become. The priest would be forced to polish the illusion through disingenuous arguments or risk inadvertently stumbling into the God paradox.

Simply put, the God paradox says that if God is all-powerful, He cannot be all-good, and if God is all-good, He cannot be all-powerful. Epicurus put this best in the fourth century BCE:

Is God willing to prevent evil, but not able? Then he is not
 omnipotent.
Is he able, but not willing? Then he is malevolent.
Is he both able and willing? Then whence cometh evil?
Is he neither able nor willing? Then why call him God?[13]

The Bible speaks of a God who intervenes among persons and communities. The Bible tells us that even the hairs of our heads are numbered, and that God is our ever-present help in times of trouble. We want desperately to believe in a God who loves us and cares about our fate. This is the message that Christians hear most from clergy who seek to polish the illusion. This message is carried on and perpetuated by members of the clergy everywhere. This is what the clergy do — they soothe the faithful in bad times to ensure the permanence of the illusion when it has been dulled by the God paradox.

On days when the sun is shining and the birds are singing, it is easy to live comfortably inside the illusion that a benevolent universe will provide for our every need. We feel that we are being embraced by a loving God who will care for us. But when a tantrum of nature, a tragic accident, a life-threatening illness, a financial crisis, or the loss of a loved one disrupts our comfortable existence, we are jolted back to reality. It is during those instances that we rediscover how vulnerable we truly are. There are potholes in life that demolish our illusions and shatter our easy comfort.

The Joplin tornado had nothing to do with God. The good people of Joplin were not being punished by a malcontent deity. There was no malevolence in the tornado, only indifference. To try to moralize the destruction is futile. We often think that bad things happen to us because we have done something bad and must be punished accordingly because we are somehow unworthy of God's grace. This can drive some into despair as they try to assuage their assumed guilt, while others seek scapegoats to blame for the calamity. The religious right has often been known to blame natural tragedies on what they consider blasphemous acts like gay marriage. In doing so, they manage to use a natural disaster as "proof" that God hates the same people whom they hate — but this, too, is an illusion.

Tornadoes are among the most capricious of disaster agents. On a whim, they can completely decimate every building on one side of a street while leaving the other side unscathed. The owners of the destroyed homes might think, "What did I do to deserve this?" while the people across the street might praise God for sparing them. But in truth, both of these sentiments are but illusions and give way to the inescapable tangle that is the God paradox.

There is simply no simple exit from the God paradox. Like a Chinese finger puzzle, the harder we pull, the tighter the grip becomes, resulting in an elaborate web of even more unsolvable half-truths. And the more we try to work the story, the more entangled we become. A priest's whole congregation would need to wrestle with this. No doubt the priest would need to spin more yarns for the faithful in the process, thereby polishing the illusion that God is our personal nanny and the guarantor of our wellbeing.

The only graceful exit from the God paradox is to acknowledge that the situation at hand has nothing to do with God and the tornado exists beyond the realm of religious understanding — the tornado is indifferent to our fate. It neither knows nor cares whether we are old or young, saints or sinners, just or unjust. It simply runs its course according to the immutable laws of weather systems.

Life is full of catastrophes. Floods, fires, earthquakes, landslides, storms, asteroid strikes, volcanic eruptions, and tsunamis are all part of Earth's natural balance. Diseases, crippling injuries, birth defects, and all sorts of infirmities coincide with the human existence. What's more, we too are sources of misery for other humans; wars, slavery, crime, torture, oppression, persecution, and discrimination are all human inventions.

No one gets out this life alive. There have been five mass-extinction events in Earth history, and each has destroyed as much as 80 percent of all life on the planet.[14] We are now in the sixth extinction event, but this Anthropocene extinction event is of human origin.[15] Because we have polluted the planet, destroyed precious ecosystems, and filled Earth's atmosphere

with ozone-depleting greenhouse gases, human life on Earth may well be drawing to an end.

Throughout cosmic history, creation and destruction have been inevitably linked. Earlier generations of stars burned through their hydrogen fuel and then exploded, seeding space with heavy elements that were then used to build new generations of stars and planets. The iron in your blood and the calcium in your teeth were created from the dust of dying stars.[16]

All of nature follows the same cycles of destruction and rebirth that have spanned thousands, millions, and even billions of years.

To think that God is somehow responsible for our tiny, insignificant personal wellbeing is simply a grandiose illusion. And unfortunately, members of the clergy often preach this illusion with plenty of help from the Bible to support this notion. Indeed, much of a pastor's mission is to pray for ailing Aunt Maggie's health or to explain why God allowed young Steve to lose his leg in a tragic motorcycle accident.

But we must accept the fact that God has nothing to do with any of this. Everyone gets sick and dies. Some die young while others die at a ripe old age. Death and tragedy stalk us all, and no amount of prayer or religious observance can change this. Beyond taking some mundane precautions like wearing a helmet on a motorcycle or preparing for inclement weather, there is actually very little we can do to control our inevitable demise.

CHAPTER 2

The God of Volcanoes

I once had a question about volcanoes that launched a spiritual inquiry. Why are there volcanoes? They cause so much death and destruction. What purpose could they possibly serve? And, why would God allow them to exist at all? It is hard to fathom the destructive forces of nature.

Humans expect to be safe and comfortable in our "normal" lives. But at any point, we can be overcome by a volcano or another natural disaster that is far grander than our feeble human attempts to survive. Is this any way to run a planet? But as I contemplated the seemingly pointless conundrum that pushed me closer and closer to the God paradox, it slowly became clear to me that the forces of destruction are also the forces of creation and regeneration.

Nature is not overtly hostile to human life, just indifferent. The Yellowstone volcano will erupt every 600,000 to 800,000 years.[17] It has been 640,000 years since the last eruption. We are within its eruption window already and have no way of knowing when it will happen. When it does erupt it could take out most of the United States.[18] When it erupts, the volcano will not concern itself about who is just and who is unjust — it

will erupt according to its own cycles and without any consideration for the effects it will have on human life or the rest of the ecosystem.

What destroys can also create. Anyone living on the islands of Hawaii or Iceland knows this. The destructive force of volcanoes built these entire islands. And volcanoes do so much more; they release water vapor and various chemicals into the atmosphere; they nourish and enrich soil with raw minerals; they bring diamonds to the surface from their birthplace deep in the mantle.[19] Without the destructive and creative power of volcanoes, we wouldn't exist. Over 650 million years ago, the Earth was a frozen wasteland[20] until the tectonic plates shifted and a thousand-year span of continuous volcanic eruptions warmed the planet and enabled the Cambrian explosion[21] with the most magnificent flourishing of life that the planet had ever seen.

Of course, volcanoes are not alone in their destructive power. When I first moved to California, my family back in Iowa thought that it was very unwise for me to move to earthquake country. I considered my boyhood days in Iowa, which is prone to tornadoes, thunderstorms, ice storms, blizzards, and flooding. By comparison, California's earthquakes seemed manageable. I would guess that more people die in Iowa blizzards each year than have ever died in a California earthquake. Most of the deaths in Iowa are from shoveling three feet of wet snow off sidewalks and driveways.[22]

That is all to say that there is no completely safe place on Earth. Spread across the Earth, there are hurricanes, tsunamis, wildfires, avalanches, landslides, life-threatening droughts, crop failures, floods, meteor impacts, not to mention diseases and epidemics, as well as war and violence all seeking to do us in.

Where you live could help determine the perils you will face, but no place is safe. California does have earthquakes, but it does not have hurricanes because of its cold ocean. It is also mostly free of tornadoes and thunderstorms, but suffers from wildfires. Life on Earth has its perils. And, when we take a big picture view, it becomes apparent that these are just a normal part of the circle of life and the paradox of creation.

Everything is being created and destroyed in endless cycles, and we are living in the construction zone without safety harnesses or hardhats. What's more, we are endangered by hazards even beyond Earth. We constantly face the threats of asteroid bombardments; gamma ray bursts can fry a planet from thousands of light years away; coronal mass ejections from the Sun could wipe out a planet's worth of telecommunication and GPS signals, leaving us floundering in the dark; blowtorch-like jets from pulsars can destroy whole solar systems from across galaxies.[23]

Scientists believe that the universe was created from the Big Bang. The name says it all. The Big Bang was the Universe exploding into being from nothingness. The Big Bang created space, time, matter, and energy in the process. We know this because the universe is known to be constantly expanding. If we track its expansion backwards in time, we eventually come to the moment of the Big Bang. The only two elements to be created in the Big Bang were hydrogen and helium. All of the heavier elements up through iron had to be produced in stellar furnaces. Stars created the heavier elements in their cores through the process of atomic fusion. Then, at the end of their lifetimes, the stars exploded, spreading their treasure trove of heavy elements into space.

Once a star produces iron, it is doomed. The fusion of iron requires more energy than it produces, and without the radiant energy from fusion pushing outward on the star, the star can no longer sustain itself against the pull of gravity, and it collapses. It then explodes, sending its detritus across the heavens, forming new stars and their planets from the debris. Elements heavier than iron can only be formed by the supernova explosion. The iron in our blood, the calcium in our bones, and the oxygen in our lungs were all born of stardust.

The Universe is the product of a cycle of creation and destruction. The word "disaster" came from the Latin for "bad star," during a time in which comets were seen as celestial omens of doom.

In some five billion years, the Sun will swell up into a red giant and swallow the Earth.[24] But even before this happens, Earth will have already become

nothing more than a burnt out wasteland, scorched by heat and sterilized by radiation. It is estimated that within a billion years the Earth will be un-inhabitable due to natural processes. But humanity's toll on the planet may make it uninhabitable much sooner due to habitat destruction, pollution, climate change, or nuclear annihilation.

Creation and destruction, two names for the same processes. How can we, such young, small figures in the vast universe, possibly survive this cosmic maelstrom? We were born to survive. Life is tenacious and so are we.

CHAPTER 3

Illusions

When life is more than we can bear, we create comforting illusions to ease our minds and make life more palatable. But there is no maliciousness in crafting illusions. Rather than defining illusions as falsehoods, I would classify them more as an overlay on reality. Like the hard-shell case on a smartphone, our illusion acts as a barrier, absorbing the shocks of life and helping us to carry on and maintain the feeling of being in control.

When a child dies, we maintain the illusion that the child has moved on to a better place. With this illusion, we can even hope that we will eventually be reunited with them. This hope for reunion is a coping mechanism and a poultice for our very real pain. It sustains us and allows us to continue on. Such comforting illusions serve a vital function, for without such hope, our lives might become impossible to bear.

A friend loses a job and cries, "I do not know how I will make it! I have a family to support and no income or savings!" The best response to a religious person might be, "God will take care of you as He always has." However, it would be easy to claim that the comforter is being disingenuous. No one knows how things will work out for the unemployed person.

What the comforting person is doing is assuaging their friend's panic with an illusion. In doing so, she may unknowingly prevent a suicide attempt or other tragic outcome. She is providing hope where none exists. Sometimes illusions are all that we can hold on to.

Even the most secular of people need some sort of comforting illusion at some point. Responding to a secular person who has lost their job, one might say, "Companies are hiring now — you'll be sure to find a new job soon." Again, this could seem disingenuous depending on the circumstances. A more honest response in some cases might be, "You were terrible at your job, and I am surprised that you lasted as long as you did. Any company would be crazy to hire you." Sometimes illusions are the kindest thing we can muster. Honesty sometimes hurts.

There is perhaps no more sophisticated example of a comforting illusion than the changing of the guard ceremony at Arlington National Cemetery. Think for a moment what true warfare looks like; think of what it looked like on Omaha Beach on June 6, 1944. Imagine the mangled bodies thrown back against bloodied sands by machine gun fire; imagine the men, some only teens, trapped in flaming tanks and landing vessels; imagine the chaos and horror of war.

Now think of the changing of the guard ceremony at Arlington National Cemetery, a choreographed, idyllic scene of strength and bravery with shining chrome untouched by gore and the smooth striding rhythm of a militaristic perfection. Like polished toy soldiers, the guards march in perfect rhythm, their heels clicking with each step and turn. The young guards with smoothly shaved faces are a stark contrast to the haggard, tattooed, broken men who have seen battle. You'll see no Arlington guards with prosthetic limbs or scarred faces from IED blasts. You'll see no homeless vets with potbellies and infantry tattoos. What you see is a carefully manipulated illusion.

War isn't synchronized soldiers in white gloves marching on shining marble steps — it is grisly and bloody, with lives lost and horror befalling the innocent like hell on Earth. We cling to the choreographed illusion of

cleanliness, order, and precision as depicted with the changing of the guard ceremony to comfort us as we send our brothers and neighbors into the uncleanliness, disorder, brokenness, and chaos that is the reality of war.

Sometimes we can hold on to our illusions too tightly or for too long. When I taught my son to ride a bicycle, he began by using training wheels. At first the training wheels helped, but they soon became a hindrance. A bicycle is designed to lean from right to left to allow for proper use, but training wheels restrict this ability.

As my son rode his bike from the street, up a driveway, and onto the sidewalk, the training wheels would hit curbs and other obstructions, causing the bike to crash. Without the training wheels, such maneuvers would have been easy. The very training wheels that had been used to teach him to ride became an encumbrance that prevented him from riding properly.

There is much in the Christian tradition that, while sometimes of benefit, can become harmful and cause problems like the training wheels on a bicycle. It can be very difficult for some people to let go of their training wheels or security blankets and face the underlying issues that face them.

In time we learn that there is no Santa Claus and Christmas presents do not just magically appear — they must be bought and paid for. What's more, quality and quantity of those presents are intimately tied to the family's economic situation. Some kids will get a pony while others will get an orange and a pair of socks. Setting aside our illusions and confronting reality is all part of growing up. If we fail to set aside our illusions when the time comes, the same illusions that healed us could become our downfall.

CHAPTER 4
Astrology as a Religion

A strology is a system of beliefs that is normally described as a pseudo-science. But astrology is better served as a case study in religion. When we understand astrology as a religion, we are better prepared to understand the nature of religion and how it establishes a hold over people's lives.

In ancient times, astrology and astronomy were one. Both involved scanning the heavens for signs and portents. Astronomy is the scientific study of the motion of the stars and planets, celestial objects, and the universe as a whole. Astrology, however, is used to understand the mystical meanings behind these celestial motions. To the ancients, there was no boundary between astronomy and astrology, the scientific and the mystical, and any attempt to describe such a boundary would have been seen as absurd. Ancient astronomy was necessary for several reasons, including timekeeping and navigation. If you find the North Star, you will be given both your directions and your latitude. The North Star, or Polaris, sits almost precisely above the Earth's geographic north pole, so it shows you true north. Using a sextant, the angle at which Polaris appears above the horizon is your latitude.

Astronomical observations can also serve as a clock and calendar. The movement of the constellations helps to indicate the seasons. When ancient people saw Orion, they knew that winter was upon them. The Sun marks the hours of the day and the moon marks the days of the month. The Four most crucial observations in astronomy are the dates of the two solstices and two equinoxes. These four days mark the beginnings of each of our four seasons. If you can discern these dates, your calendar is set for the year.

Knowing the season and time of year was critical for ancient tribes. These groups' survival depended on their understanding of the periods of hot and cold weather, rainy seasons, and droughts, as well as more rare events like floods, the ripening of fruit, animal migrations, and fish spawning. But most importantly, they needed to know when the right time was to plant their crops. To find these key dates, the ancients needed only to discern the movement of the Sun and stars. Understanding astronomy was so important to societies of the past that stories of these star cycles were woven into various cultural heritages as sacred texts and lore as a way of maintaining this knowledge throughout generations.

Tying valuable information to folklore and entertaining stories has always been a way of helping to ensure information retention. As a Boy Scout, I was taught to remember how to tie a bowline knot with the following mnemonic: "The rabbit comes out of the hole, goes around the tree, and back in the hole." This is something that I have never forgotten. Similarly, ancient civilizations would use the constellations and their stories to tell them what part of the year it was.

The science of astronomy diverges from the religion of astrology because of superstition. Superstitions can be described as actions that are believed to be causally connected to the desired outcome but actually are not connected.

We get a boost of confidence and comfort from our superstitions. A gambler believes that wearing his favorite hat enhances his luck in poker. A job candidate may believe that she must always get a mocha latte before her interview if it is to go well. A football fan insists that he can't wash his team's

jersey or they'll lose the big game. All such actions qualify as superstitious because they have no causal impact on the outcome — they are not part of the chain of causality. While superstitions might have no consequential effect on our lives, it is undeniable that they can offer comfort; such is the power of any illusion.

As with superstitions, there are all sorts of occurrences and objects of note in the night sky that are not a part of any causality. The motions of the planets certainly seem important, but in reality, there is no scientific evidence of any correlation to their paths and our lives. The arrival of comets, eclipses, meteor showers, planetary conjunctions, and many other events, no matter how stunning or seemingly mystical, have little if any impact on our lives on Earth. Human civilizations of old did not know which celestial events were portents of things to come, so they believed that everything that happened in the sky was important.

That is not to say that astrology is based entirely on antiquated, superstitious beliefs. There are certainly a few basic tenants of astrology upon which we can all agree. The Sun, the Moon, and all of the planets move along a vast racetrack in the sky. In astrology, this track is called the zodiac. Astronomers call this same track the ecliptic because solar eclipses can occur when the Moon crosses the ecliptic at just the right time and place to block the Sun.

The Sun and all of its planets were formed out of the solar system's accretion disk, which was a spinning cloud of dust and gas that formed the Sun, the planets, the asteroid belt, and the Kuyper Belt objects. They are all on the same plane and follow the same course across the sky. Our Moon, however, is slightly different. Instead of being formed from the accretion disk, scientists believe it was formed when a Mars-sized planetoid called Theia collided with the Earth around 4.5 billion years ago. The Moon's orbit is a mere 5.5 degrees off of the ecliptic, so for the sake of convenience, we will say that the Moon shares the same ecliptic path as the Sun and planets.

Here is where astronomy parts company with astrology, however. Astrologers will tell us that the sun moves through the 12 houses, or constella-

tions, spending 30 days in each house. This certainly seems to align with our Gregorian calendar system based on astronomy, which in turn makes the illusion feel very predictable, accurate, and comforting. The problem is that the scientific facts tell a different story:

1. In truth there are actually 13 constellations on the ecliptic. Astrologers conveniently ignore Ophiuchus because the addition of a 13th constellation would mess up their cherished symmetry of design. Twelve is the symbol for cosmic order. There are 12 months, 12 hours in a day, 12 tribes of Israel, 12 apostles of Jesus. Twelve is the number of perfection.

2. Some constellations are much larger than others. It takes the Sun only seven days to cross Scorpio, but 45 days to cross Virgo, so the 30-day concept is actually more of a general average used to maintain the illusion of symmetry.

3. The astrological calendar is seriously broken. It is based upon ancient positions of the stars that are no longer correct. Star patterns shift over thousands of years due to the precession of equinoxes. In reality, the astrological calendar is off by about 25 days.

Furthermore, even within the astrological community, there are dissenting opinions about the celestial interpretations. An astrologer can insist upon the validity of their predictions and conclusions, but the matter stands that there is no body of evidence to test any astrological statements. Because of this, the astrological pseudo-science religion is a perfect feeding ground for frauds and grifters who claim to read the stars and examine your fate, but always for payment.

Thinking that the position of the planets at the date of your birth can somehow affect your personality or destiny is perhaps the purest example of a superstition as it is defined above. The gravitational effects of the obstetrician during your birth would probably have millions of times more effect upon you than the position of Jupiter in the night sky.

I have always been vexed by people who are intelligent but nevertheless espouse nonsense about astrology. In the past, I tried to argue, explaining that scientific facts, as mentioned above, prove the lack of causality to be found in astrology. Without fail, they are nonplussed and respond that I just don't "get it." They seem content to ignore facts and logic and believe in something that is nonsense.

But then, all of a sudden, I understood. Astrology is just another religion. Religions are full of beliefs in what might be considered nonsense. If a Catholic can believe that Jesus is contained in a wafer, if a Muslim can believe that creating an image of Mohammed is blasphemous, if a Jew can believe that eating lobster is sinful, and if a Mormon can believe that God revealed himself through a magical scroll that appeared and then disappeared, perhaps it is no more fantastic to believe that the position of the planets at the time of your birth controls everything from your personality to your destiny.

For many, astrology acts as their connection to the universe, enabling them to feel like a part of the cosmos and experience the transcendence that is common to all religions.

While President and Mrs. Reagan publicly proclaimed themselves as evangelical Christians, another religion that was very much a part of the Reagan household was astrology.[25] When President Reagan was shot, Nancy used her astrologers to schedule key meetings. In later interviews, she explained how important astrology was to her; with her world falling apart, astrology gave her a sense of comfort and control.

Religion might be said to be a deep-seated human need. It offers believers a source of comfort and sense of security, no matter how illusory; it connects tribes and people with the cosmos and their place and time in it; it is a set of beliefs that organizes and orders our lives to make them seem more manageable — to some, astrology is no different.

For believers of astrology, the pseudo-science almost literally connects them to the transcendent heavens, giving them an actual position in time and

space as a part of some grand, cosmic pageant. Based on these conclusions, astrology is clearly a religion and not a pseudo-science.

Using astrology as a case study in religion, let's talk about how it can be beneficial or detrimental.

If a person uses astrology to feel connected to the cosmos, giving themselves a sense of participation and meaning, this is all well and good. Likewise, if they like to read their horoscope in the newspaper as the sip their coffee, more power to them — no harm is done, and it's all in good fun.

However, if that person were then to go off to work and make decisions on hiring or promotions based upon a worker's astrological sign, what had once been harmless now becomes foolish and inherently unjust. This could be considered a form of discrimination no different than using race, sex, national origin, or religion to select a candidate. Employers are not allowed to use any criterion for selecting candidates that does not relate to the actual job skills required.

Just as a restaurant cannot advertise specifically for a female waitress, which would be discriminatory based on gender, advertising solely for a Capricorn waitperson is discriminatory based on religion. It would be foolish to demand a Swedish carpet installer because someone's nationality has nothing to do with their job performance; for the same reason, it would be foolish to demand a Taurus carpet installer — foolish, immoral, and illegal.

So, while it is acceptable to use astrology for one's own private amusement, it is not acceptable to bring one's own idiosyncrasies into the marketplace. The same principles also apply to every form of religion. While a fundamentalist Christian may not believe in premarital sex, and a Jewish person might not believe in eating lobster, it would be absolutely unjust and illegal to discriminate against a single mother or someone who brought seafood leftovers to the workplace.

A final note of caution to followers of astrology is to take the advice you find through your horoscope with a grain of salt. If your horoscope says

it is your lucky day, feel free to buy a lottery ticket or drop $20 in a slot machine — again, all in good fun. But it is unadvisable to mortgage your house or empty your 401(k) retirement savings before hitting the casino. It would be folly to end a long-term relationship, undergo dangerous elective surgery, or make other major life decisions, simply because your horoscope suggests it. Should you *already* be planning to do these things, your horoscope can be a welcome source of comfort and motivation.

As is the case with any religion, astrology is an illusion with no basis in scientific fact.[26] The validity of astrology is called into question not only by the forged and outdated astrological charts I mentioned above, but also, there remains to be seen any evidence to tie any celestial event found in those phony star charts to any predictions that can be objectively verified. Let us say, for instance, that Venus has moved into a believer's house, or their zodiacal sign, at the same time that a new relationship has begun and their roof springs a leak.

While an astrologer might attempt to explain in an impressively mystical way that these events were caused by the heavens' movements, is there truly any quantifiable way to prove that this was really the case? Even if astrology was seen as the one true religion, there is no possible way to prove that these terrestrial life events did not occur as a result of some coincidence and the stars are active in another way.

Ivan Kelly, who teaches psychology at the University of Saskatchewan, has written many articles that are critical of astrology. He believes that astrology can neither assign a person their personality traits nor help someone understand their place in the cosmos.[27] Modern advocates of astrology cannot account for the underlying basis of astrological associations with terrestrial affairs, have no plausible explanation for its claims, and have not contributed anything of cognitive value to any field of the social sciences.[28] As such, astrology may find its comfortable place in society among the other unproven, unquantifiable religions of the world.

CHAPTER 5

When Illusion Becomes Delusion

On average, the modern English versions of the Bible contain approximately 800,000 words. Over the course of many centuries, the words of the scriptures were passed down from person to person in the oral tradition until they were eventually written and copied over and over by thousands of people, who slightly reinterpreted the gospel according to their languages, historical circumstances, and religious understandings. With such a wide margin of error and with so many potential variables that would allow for confusion and reinterpretation, grasping tightly to a strict reading of a scripture statement is folly.

What's more, even if the text of the Bible somehow was entirely authentic and untainted by human error, no one could possibly retain and recall verbatim all 800,000 words of that text. Therefore, any religious person's grasp on their faith consists of a selective summary of what they can recall from the tome. The themes they draw from the Bible can vastly differ from another person's for this very reason. However, I believe that everyone on a faith journey follows this same process to create a construct of what their beliefs are. Going forward I will refer to these selected summaries as "constructs."

Let's look at the "five fundamentals" of the Christian faith, from which we gained the term fundamentalism.[29] The five fundamentals, according to fundamentalists, are:

1. The inerrancy of scripture.

2. The divinity of Jesus Christ.

3. The virgin birth.

4. The bodily resurrection of Jesus.

5. The substitutionary atonement of Jesus on the cross.

Out of the approximately 800,000 words of the Bible, these five premises act as the basic principles with which Christian fundamentalists formulate their religious beliefs, or constructs.

Regardless of their religious traditions, denominational identification, or any other predisposition, and whether they know it or not, everyone has created some sort of religious construct from which they draw their understanding of religion.

My personal construct vastly differs from that of the Christian fundamentalists. If you were to ask me what my faith entails, I would respond with Micah 6:8, "And what does the Lord require of you but to act justly, love mercy, and to walk humbly with God?"

A conservative Jew might say that his construct is centered on the importance of keeping kosher; a frontier evangelist might say that the most important thing is to be born again; an institutionalist may say that the pinnacle of his construct is to go to church every Sunday, fulfill all ritual obligations, and to tithe; the pietist might say that refraining from sex outside of marriage, not drinking, dancing, smoking, or gambling is the key to Christian faith, while another might say the most important thing is to spread the Gospel. It could be said that there are as many potential Christian constructs as there are people who call themselves Christians.

Simply speaking, those who consider themselves Christians do not necessarily embrace all 800,000 words in the Bible, but rather simplify and condense the message in a way that is more comprehensible to the believer's existing mindset.

When a person becomes deluded in their religious beliefs, they can take their obsession to extremes, and the gentle believer can transform into a hateful, violent fanatic. The fanatic believes that his religious construct is more real than reality. He no longer dwells in the world of his senses but rather moves into a virtual reality of his own — or his religion's — creation.

In this delusion, the believer's God has the same prejudices as he has and hates the same people as he does. Let us assume for a moment that this deluded fanatic is an anti-abortion protester whose construct of the faith demands that he take action to stop all abortions. He hangs around abortion clinics, harassing those who seek to have an abortion, including young girls who have been victims of rape or incest. Given his construct's ordained mission, bombing the abortion clinic is not out of the question. It is not even a sin, because, after all, he is doing God's work! Because of the construct he has gleaned from the Christian faith, he believes that he is actually saving lives by murdering doctors, nurses, patients, and receptionists who work in abortion clinics.

He has abandoned the world of normalcy in which murder is wrong, and ordinary laws do not apply to him as he pursues his higher calling. He is now an emissary of the almighty God and is sent to do His bidding.

CHAPTER 6
When Religion Turns Toxic

When religion turns toxic it can become one of the most destructive forces on the planet. The Crusades, the Inquisition, the genocidal conquest of the New World, the Ku Klux Klan, the European and American witch hunts, Islamic terrorism, the slaughter of Muslims in Myanmar and western China, and the homophobic actions of the Westboro Baptist Church are all examples of acts of hatred motivated and justified by religious fanaticism.

Of course that is not to say that all religion is toxic. A believer's expression of faith can have beautiful, life-changing effects on those around them and the world as a whole. There are religious beliefs and practices that transcend our ordinary existence, and make us one with the divine, the cosmos, the world in which we live, and our fellow travelers on this journey through life. Think of Jimmy Carter building houses for Habitat for Humanity at 94 years of age; think of the gentle spirituality of the Dalai Lama; think of Albert Schweitzer or Saint (Mother) Teresa of Calcutta giving their lives to serve the poor; think of the divine transcendence of Taizé worship, wherein Christians and non-Christians of diverse tribes come together to focus on the God of all; think of the Bahá'í faith and its nine doorways of enlight-

enment; religious devotion is not always toxic — it can be truly humbling and beautiful.

But to differentiate between fanaticism and devotion, one must recognize the signs of burgeoning toxicity and nip them in the bud.

Tribalism

Throughout its history and even its prehistory, humanity has been organized into tribes. These tribes can be formed based on bonds of kinship, race, ethnicity, nationality, language, lifestyle, religious sects, or any other demographic type through which we might form the basis of our identity. By nature, humans are social creatures, so tribes are essential to our existence. Our tribal membership is an overwhelming factor in how we live, act, think, and believe, forming the basis of our very cultures.

Tribes offer community, which is essential to human life. But the dark side of tribal membership is that it can, and often does, separate us from those who are not of our tribe. Our religious tribes are no different — Christians bond to Christians, Muslims to Muslims, and so on. Like follows like, and this is the way of the world. Of course it is best to attempt to push beyond those tribal boundaries and try to understand if not encompass others' world views, but sometimes a lack of animosity is the best humanity can achieve.

However, if the ideological perspective of your religious tribe allows or encourages you to hate another tribe simply because it is different from yours, this is a sign of toxicity. If your tribe insists that it is the standard by which all other tribes must be judged, it is toxic. If your tribe proclaims superiority over all other tribes, it is toxic. Recognize and understand the red flags and take a step back to evaluate before you fall into the trap of your tribe's obvious delusion.

True spirituality rejects superiority and embraces inclusiveness, encouraging you to learn about the ways of other tribes and understand the wisdom gleaned from diverse sources. A mountain may be climbed by many differ-

ent paths, yet it is the same mountain with the same summit. The path that we choose may be the favorite path of our tribe, well worn by others in our tribe's long history. We know each step and handhold from those who have climbed the path before us, but to really understand the entire mountain, we must get to know the paths others have climbed.

Absolutism

Absolutist religion of any sort is highly toxic. When a tribe believes that it alone possesses the truth and all other tribes are misguided infidels, there is no room for compromise or even dialogue in their ideology. As such, the absolutist tribe sees fit to punish or even exterminate the supposedly godless heathens who follow a different path. Even tribes that share a large portion of their beliefs with the absolutist tribe can still be singled out contemptuously and persecuted for their lack of resolve in the one true way. Intra-religious warfare between Protestant and Catholic Christians, and Sunni and Shia Muslims can be even fiercer than inter-religious rivalries. It is either all or nothing with absolutist religious tribes — join or be punished.

Control Needs

Toxic religion seeks to control others. Freedom of religion begins with freedom from the religion of others. The fanatic believes that they alone speak for God, they alone can interpret their tribe's sacred scriptures, and that they have the right to rule over others.

However, those who most demand strict adherence to the sacred scriptures seem to have read them the least. This is often true of the Christian fundamentalist. *The scriptures are the word of God passed down to us from God to ensure our salvation. It is complete and inerrant and not to be questioned!* However, after saying that, they begin to spout their own personal beliefs and prejudices, citing them as God's word.

The Bible says yoga pants are a sin! That's strange. The Bible seems ripe with analogies of fertility and sex. *God helps those who help themselves!* No scrip-

ture ever says this. *The Bible says to be fruitful and multiply, so abortion and contraception are evil!* Neither were explicitly forbidden in the Bible, so this is just a fabrication.

To argue with those who confuse God's word or manipulate it to suit their own personal prejudices and opinions will not only be unsuccessful, but will also yield bitter animosity and headache. These sorts will accuse you of all manner of sins and tell you in no uncertain terms that the problem is with *you* and that *you* need to be saved because *you're* blinded by sin and corruption.

An in-depth reading of the Christian gospels actually reveals that Jesus spent a lot of time and energy disputing the Pharisees and Sadducees who were the religious zealots of His day. They were hyper-religious, self-righteous, fanatical control freaks who believed that they alone could interpret the scriptures and speak for God. Jesus preferred the company of Roman tax collectors, prostitutes, and sinners. Yet this is often conveniently forgotten by the modern hypocrites who mimic the Pharisees of yore.

Living in a Fantasy

Some tend to believe that God is a benevolent wizard, who, with a wave of His magic wand, will fix everything that is wrong in the world. Global warming? God will fix it. Ebola? God will fix it. Hurricane damage? God will fix it. But this belief system is always accompanied by the stipulation that we must first appease Him; until God is satisfied with our good works in His name, He will sit resolutely unaffected by our plight. As such, these believers insist that our societies must be ordered around God's will in order to secure His blessings and save humanity from itself. This normally leads to the purging of those in their midst whom they consider undesirable or unworthy.

Without a scientific understanding of the world, people tend to wallow in superstition and expend their energies trying to appease an angry god to no calculable end. While the idea of primitive tribes throwing virgins into volcanoes to prevent eruptions might seem archaic and disconnected from

our modern perceptions, it is an apt analogy for the way in which some religious followers approach the world and their god. Just as the volcano is indifferent to the human lives offering a tragic sacrifice, so too is the Ebola epidemic indifferent to thoughts and prayers.

Put yourself for a moment into the mind of an ancient tribesman. You are weak of flesh and need protection from the beasts of the world. You need to hunt and kill animals for their meat, bones, and hides. You need the herds to migrate on time to ensure your hunting schedule is uninterrupted. You need fertile fields and abundant crops. You need rain at the right times and in the right amounts. You are powerless over the forces of nature that can bring storms or fair weather, abundance or starvation. Your security and sustenance are always uncertain, and survival is a daily struggle. As such, you will do anything to appease an angry or neglectful god so that you might prosper. From this desperate mindset, religious institutions were born, and though they have evolved over the millennia, this basic equation of need fulfillment in exchange for obedience and devotion has remained.

God's wrath brought down the hurricane to punish us for accepting gay marriage! Measles has returned because abortion is legal! My standard reply to such absurdities is that if God did not smite the United States over chattel slavery or genocidal warfare against the Native Americans, we can be assured that He is not losing any sleep over gay marriage.

At the other end of the spectrum, there are those who believe that no matter what we do or what befalls us God will protect us. *Climate change? No big deal — God will protect us! Nuclear war? God won't let that happen! Untillable, poisoned land? We destroyed our ecosystem, but God will feed us manna from heaven.*

But as the famed cosmologist Carl Sagan once said, "There is no one coming to help us."[30]

Those who refuse to look at the world scientifically live in a false reality. They refuse to accept facts, logic, or common sense and are sure that the religious ideology that they have been taught is the only way to view the

world. What's worse is that their religious ideology becomes a closed loop system that proves itself true, and everything outside its narrow bounds proves itself false in a vicious cycle of denial. Those who feed into their own cyclical religious ideology are willfully ignorant of the very real and present dangers that threaten to destroy civilization.

We can survive and thrive as a species but only if we learn to support each other, even as it extends beyond our specific tribe and ideology. We must manage the Earth as its trustees. We need to lessen the effects of global climate change, nuclear proliferation, pollution, poverty, and hunger. We need to work to create a sustainable economic system that can provide food, shelter, potable water, energy, education, and healthcare for all of Earth's people.

Rain is caused by weather systems. The rain falls on the just and the unjust. Diseases are caused by bacteria, viruses, parasites, and our own genetic inheritance. God has nothing to do with these concerns. Nature neither hates nor loves us but is completely apathetic — there is no one coming to help us.

CHAPTER 7
The Root of Religious Discord

As I noted in a previous chapter, no one can mentally absorb and regurgitate verbatim all 800,000 words of the Bible, so from the most personally relevant information, a person creates their construct. Ideally, these constructs are internally consistent. A tight, well-regulated system can function like clockwork as long as it is not challenged by outside ideas or external constructs that clash with its foundations.

When someone's construct becomes their entire world view and they are presented with a differing construct, the seed of discord is sown. If only your construct is right, anyone else's is wrong.

When I was a pastor, I knew a young woman who had been baptized as an infant and raised Presbyterian. She was marrying a Baptist and would be joining his church, but the Baptists required that she be rebaptized!

The children of Presbyterian believers are ordinarily baptized as infants. During the baptism, both the parents and the congregation vow to raise the child in the Christian faith. The baptism ceremony is an act of God, separate from human will, in which God claims the child as part of the

Christian community. In the Presbyterian Church, baptism is seen as a complete and final act that does not need to be confirmed when the child reaches the age of consent.

While Presbyterians do offer "commissioning classes" for adolescents when they come of age so they are prepared to participate more actively in the life, worship, and governance of the church, we firmly believe that an infant's baptism is entirely sufficient for the believer's entire life.

Baptists have a very different view of baptism that clashes radically with Presbyterian tradition. That is not to say that one view is "right" and the other is "wrong," but the two sets of doctrine simply cannot mesh together.

To join the Baptist Church, this young woman was required to undergo a Baptist believer's baptism, while Presbyterian doctrine eschews any form of rebaptism.

If this woman did not undergo a Baptist believer's baptism, she would only be considered a sojourner in the Baptist church and not a full participant. Baptists believe that only a full believer's baptism, entered into by someone old enough to consent to the proceedings, is a valid sacrament in the eyes of God.

Further differentiating the two types of baptism is the amount of water used. Baptists generally baptize believers with a full-body dunking, while Presbyterians opt to sprinkle water on the head. Granted, the very word "baptize" means to dip or dunk. Personally, I do not believe that the amount of water used in a baptism is of any more significance than the amount of Eucharist consumed during Communion. Just as a church does not need to provide each congregant with a full meal to celebrate the Lord's Supper, one does not need to be fully submerged in water to be baptized in the eyes of God.

In order to be a part of her husband's faith, this young woman had to effectively deny the Presbyterian faith she'd known since infancy, disavow

her infant baptism, and scrap the spiritual growth she'd undergone in the Presbyterian faith, and start over as a Baptist.

There is nothing wrong with the Presbyterian notion of baptism, and there is nothing wrong with the Baptist notion of baptism. The problem arises when we try to combine them, resulting in discordant notes and emotional turmoil.

In truth there are no right and wrong ways to baptize or to perform any ritual really. Biblical descriptions of baptism in the early church are sparse at best, offering few details and even fewer instructions. There are only a few stories of baptism in the early church, and there are no other sources describing baptism outside of the New Testament.

It is conceivable that children of Christian parents in the early Church were never baptized at all. Perhaps the understanding was that since these children were born into the Christian community, there was no need for baptism as that may have been seen as a sign of conversion to the Christian faith. However, the fact remains that we know very little about the subject.

All rituals are merely human artifacts. Their significance and power come only from our understanding of what meaning we have ascribed to them. Baptism is simply a perfect example of this because it has been a bone of contention between the various Christian traditions since the ritual's inception. But the minutia of the ceremony is really of no consequence whatsoever. Does it really matter for anyone's life or salvation whether they underwent baptism as an infant or an adult? Will a person be more welcomed in heaven if their full body had been submerged instead of having the water lightly dribbled over their head? Of course not because baptism is a wholly human practice — one that is done in the name of God, but still one based in human ritualism. And it is wholly the human element that causes strife and discord among religious tribes.

Another example of religious discord based around man's rituals comes from the Holy Eucharist, or the sacrament of Communion. Presbyterians believe in a free and open Communion — anyone who confesses Jesus Christ as

their lord and savior is welcome to participate. Ideally they would also be baptized into the Christian community, but this is not a strict requirement. This openness comes from the belief that Communion is an outpouring of God's grace upon the assembled faithful. The Eucharist takes place at the Lord's Table, not our own — we have no right to turn away those who wish to share in Communion with others who are united in faith at one table fellowship. According to the Presbyterian tradition, all barriers should be shattered as our ecumenical community of faith communes together. In theory, we celebrate World Communion Sunday at a time when Christians throughout the world do, so that we may commune together as a sign of our ecumenical fellowship without borders or boundaries.

Catholics are not nearly as all-encompassing in the Eucharist rituals. I, for example, would not be welcome at a Catholic Communion for multiple reasons.

First of all, I am not a Catholic. The Presbyterian notion that the Eucharist is open to all of God's people regardless of their denomination is not one that is shared by the Catholic Church.

Secondly, even if I were a Catholic, I would still not be eligible to participate in the Eucharist because I am divorced. Before the current pope, Pope Francis, one needed to pursue and complete divorce proceedings in the civil courts and then appeal to Rome for an ecclesiastical annulment of the previous marriage before they could be absolved and welcomed again at the Lord's Table. However, such a process could take decades and cost tens of thousands of dollars.

Thirdly, even if I were a Catholic and had never been divorced, I would still be unwelcome until I completed all of the pre-Eucharist requirements for Catholics like attending confession and abstaining from food and drink for one hour. There are all sorts of things that need to be done in order for a Catholic to get their admission ticket punched for Communion. In the eyes of the Catholic faith, the Eucharist is not so much an open outpouring of God's grace upon any and all believers but rather a reward for the loyalty and good behavior of those Catholics in good standing.

For this reason, I always face a dilemma when I worship at a Catholic church. The Catholic views on the Holy Eucharist are contrary to everything that I, as a Presbyterian, hold dear. Instead of it acting as a sacrament to unify all Christians in one Lord, one faith, and one community, Catholic Communion breaks us down into tribal sects that are purposefully separated and forbidden to worship and commune together. In a way, it separates the "sheep" from the "goats" with the rules and preconditions for participation. But again, it is not that the Presbyterians are right and the Catholics are wrong. It is just that we have two different and radically divergent concepts of how to practice the Eucharist.

However, as I said before, our rituals, even those that are religious, are only as meaningful as we ascribe them to be; we assign all meaning to each sacrament. The regulations surrounding our rituals come only from our own traditions rather from divine decrees. Humans have created the means of our own separation and strife for millennia, and sadly, this discord serves only as a great distraction from the true purpose of the Church. None of our tribal squabbling and bickering goes to proclaiming the Gospel, feeding hungry children, rescuing refugees, or bringing people closer to God.

Since the dawn of man, we have argued and warred over everything from basic doctrine to the most infinitesimal points of ritual. We obsess over minute, symbolic details that have no importance in reality and claim that our own doctrine is so rigidly correct that yours is bordering on infidelity. Thousands of gallons of blood and ink have been spilled throughout Christian history as we have warred and debated over even the most foundation definition like that of the Trinity.

The division of Christians and Muslims might be considered by some to be the largest theological gap of our time. However, most people don't know that Islam was born of the same scripture and God as Christianity and Judaism. What set them apart was their interpretation of the Holy Trinity; some might consider this a major point of contention, while to others, it is perhaps just another example of a minute detail that has caused a historical rift. The nations of Islam generally reject the officially sanctioned affirmations of faith that were used to describe the Trinity, seeing the concept of a

three-in-one God as contrary to monotheism and therefore blasphemous. Islam recognizes Jesus as a prophet of God similar to Muhammad, but not the "Son of God" or an incarnation of Him because there can be only one God. Because of this divisional understanding of such a basic tenant, the Muslims' only solution was to reject Christianity and start their own religion approximately 600 years after the start of the Christian Church. Such is the power of words and interpretation.

Apart from religion, I doubt there is any human endeavor that engenders such obsession and fastidiousness over perceived rules and constructs. Believers demand strict compliance to the rules of faith set down by their own construct, and anyone who does otherwise is wrong — plain and simple.

I once toured Israel's biblical lands from Dan to Beersheba with a group of travelers from various Christian traditions. Along the way, I was fascinated to learn that the churches and Christian holy sites in Israel are actually managed by dozens of different religious communities.

While they are perhaps the most recognized in our society, Catholic and Protestant traditions actually only represent the Christian theology of Western Europe and its colonial empires. The Orthodox Church is far more prevalent in Eastern Europe and Asia Minor, areas that spoke Greek instead of Latin during Roman times. And that only covers a portion of it. Americans only think of Protestants and Catholics when considering Christianity, but in Israel, there are dozens more communities and traditions from Africa, India, central Asia, and the Middle East that most American Christians have never even heard of. The Church is far larger and more diverse than we could ever imagine.

As our diverse tour group came upon the banks of the River Jordan where Jesus was baptized, we were served Communion by the pastor who led our group. The Eucharist was meant to serve as a spiritual climax of our pilgrimage, but the ceremony was quickly dampened by a woman who became irate that the leader had dared to serve alcoholic wine. She carried on for quite some time about the sinful nature of alcohol and how Communion wine *had* to be non-alcoholic for the Eucharist to be pure. Of course,

this is an absurd notion, because in the First Century CE there was no possible way to keep wine from fermenting and becoming alcoholic. When nothing else would distract the woman from her rant, the leader asserted that he had actually used non-alcoholic wine. The fire in her eyes died as quickly as it had been ignited, and we continued peacefully on our tour through the Holy Land. Whether the pastor's assertion of innocence was actually true I will never know, but regardless, I know that it was necessary to quiet the storm.

CHAPTER 8

Sacred Scriptures as Human Artifacts

Once, while I was worshiping with an Episcopal congregation, I saw one of the strangest, most ritualistic displays of my life. The priest danced the large, pulpit Bible around the chancel as if it were the object of some sort of cultic veneration. This idolatrous dance was repeated several times during the service and actually seemed to be the central focus of the liturgy. The priest paraded the Bible around like some sort of sacred relic to be revered. In so doing, he proclaimed in liturgical dance what a fundamentalist preacher would proclaim with his words. Treating the Bible as an object of cultic veneration is certainly not a part of the expressed, accepted theology of the Episcopal Church nor of the global Anglican Communion. Because of this, the priest's dance seemed strangely out of context.

Christians believe that the Bible is the Word of God; to many this means that God dictated the scriptures to a series of scribes through the ages. Christian fundamentalists maintain that the Bible is inerrant and that every word of the Bible must be interpreted literally. To accept this construct, we are then forced to believe that the world was created in six days, that Jonah survived in the belly of a fish for three days, and that Job was tormented by God mercilessly in order to settle a bet between God and Satan.

Biblical scholarship reveals a far different picture. Rather than being dictated to scribes by a single voice of God, the scriptures reveal a vast array of voices, all reflecting different ideas, thoughts, and constructs, rooted in different historical circumstances. There are two creation stories in the opening chapters of Genesis. One is from an author called the Yahwist (Genesis 1:1–2:4) and the second from an author called the Elohist (Genesis 2:4–25).

There is not one Gospel but four, each written by a different evangelist from a different perspective. Mark was the first Gospel. Later, Matthew and Luke both used Mark as a starting point for their own Gospels along with a lost source that scholars refer to as "Q."[31] John's Gospel was the last and diverges from the first three. It is for this reason that inerrancy is impossible. Even the first three synoptic Gospels are impossible to reconcile with their minute differences. The four Gospels are not like four different newspaper accounts of the same event with minor changes in details; rather, they are like four different portraits painted by different artists.

The first Christian scriptures to be written were not the Gospels, but the letters of the apostles.[32] In the book of Romans, Paul writes that Jesus was the son of Joseph according to the flesh, and the Son of God according to the Spirit.

> …the gospel concerning his son who was descended from David according to the flesh and designated Son of God in power according to the Spirit of holiness by his resurrection from the dead, Jesus Christ our Lord… (Romans 1:3–4)

However, this passage is in conflict with the virgin birth narratives of Matthew and Luke, and accordingly, it is in conflict with two of the five fundamentals of Christian fundamentalism.

The more faithfully one studies the Bible through the lens of scholarship, the more one can see the human fingerprints inlaid in the scriptures and can hear the cacophony of contradictory voices within the supposedly inerrant text.

The scriptures contain many forms of literature — poetry and hymns, parables, short stories, detailed instructions for performing various rituals, and even reflections on key historical events. And each of these types of writing must be examined in different ways.

Stories like Noah's Ark, Jonah and the great fish, and Job can only be read as short stories or novellas. It is known that the story of Noah's Ark, one of the most well-recognized stories from the Jewish and Christian faiths, was actually based on a much earlier Middle Eastern legend called the Epic of Gilgamesh. In fact, the story of Noah's Ark follows the Epic of Gilgamesh's narrative to the letter,[33] further demonstrating how biblical scripture is an amalgam of various narratives rather than a single dictation.

Whatever the source, when regarding any part of the biblical narrative, the most important question to consider is not whether or not the events really happened, but rather what the text and its author is trying to tell us. The Book of Job describes how God mercilessly tormented Job, made him unbearably ill with boils covering his body, and killed his family to prove to Satan in a bet that Job would remain faithful. If this story were read as an actual history instead of the teaching parable that it is, it would be disconcerting and completely contrary to the wise and merciful depictions of God elsewhere in the Bible.

However, when the Book of Job is compared to Proverbs, more light is cast on the story. The theme of the book of Proverbs, which scholars refer to as part of the "naïve wisdom school," is that those who are pious will prosper and God will bless the righteous with happiness and prosperity. The corollary to this is that those who appear to be prosperous and happy must be blessed by God for living righteous lives. This school of thought was considered to be naïve because of its rather simplified and "Pollyannaish" tone as well as the general disconnect it reveals from life's often-harsh reality. Proverbs spouts such advice as:

Misfortune pursues sinners, but prosperity rewards the righteous. (Proverbs 13:21)

The Book of Job was written to contradict the naïve wisdom school as represented in such books as Proverbs. Job's counter-message to Proverbs is clear. Even good people are struck down by poverty and illness — it does not mean that they are sinners or that God has chosen to smite them for their lack of faith. In the same vein, there is no reason to believe that those who appear successful and prosperous live righteously and are favored by God. I'm sure we all can think of examples of both cases.

What is among the most important things to remember when studying the Bible is that most of it was actually recorded long after the fact. Much of the Old Testament was carried solely by oral tradition for hundreds of years before it was finally committed to writing. As for the New Testament, it is held by scholars that none of the four authors of the Gospels actually walked with Jesus.

Imagine, for a moment, that you have been assigned to write a history report about Abraham Lincoln from memory — you are not able to consult any history books, libraries, the internet, newspaper archives, or any public records. After all, no similar sources were available to the authors of scripture.

It's possible that you remember some details about President Lincoln from your history classes at school; you might have read some books or watched some movies about him; you may remember a few highlights of his presidency like his Gettysburg Address or the Emancipation Proclamation. Drawing from what you can recall, you might be able to write a fairly accurate history of Abe Lincoln, but more likely than not, you'll miss out a few key details or get something confused. You might incorrectly recall that he was born in Illinois instead of Kentucky, or assign the cherry tree anecdote about George Washington to his childhood instead. The important central themes might be present, but without having been alongside Abraham Lincoln or had a source of documentation about the events, your recollection and recitation would be spotty at best with many details left out.

Such is the case with the Bible. One could not describe the text of the Bible as straight, unbiased reporting of actual events. Rather, it would be best

to think of it as what it is — parabolic storytelling. After hearing count-less stories from their communities, the dozens of authors of the Bible compiled those oral traditions and wrote them down. In time, they were compiled further into the mass text of the Bible. Then, throughout the centuries, the Bible went through translation after translation with inter-pretation occasionally coloring the material. After so many centuries of this, who knows how similar the current stories are to their original form? But for this reason, the Bible is not meant to be read like an unbiased, journalistic account of actual events, but as a shared sacred narrative of the culture and theology of the Judeo-Christian community.

The Bible, along with all other sacred scriptures, is an artifact of human culture. They are oral narratives that were passed from generation to gen-eration before being written down in book form. They are not a source of magical power, nor an accurate chronicle of history. But they are a col-lection of stories that provide a common heritage for members of their religious communities.

Christians do not worship a book; they do not have a cult-like veneration for ink and page. When they speak of the Word of God, they are referring ultimately to the word made flesh, which is to say Jesus the Christ, the Son of the living God. And that is an important distinction, and what could, perhaps, even make the difference between devotion and fanaticism.

CHAPTER 9

The Inadequacy of Ancient Stories

Recently, a pastor friend of mine informed me that he wanted to study cosmology in the scriptures. Cosmology is the study of the origins, growth, and development of the universe. I told him that he was absolutely nuts. I told him that if he wanted to study cosmology, he needed to look through a telescope — begin with astrophysics, not the scriptures. I have studied cosmology extensively and even wrote a bit about it, and there is nothing in the ancient campfire stories that are the scriptures that would be of any help in this regard.

A few years ago, I met with a Bible study group made up of other clergy. Our topic was economic justice in the scriptures. I was asked to join the group because of my financial and business expertise. There were passages of scripture that we wanted to explore such as the concept of a jubilee year. In a jubilee year, all debts would be forgiven, slaves and prisoners would be freed, and all land would be returned to its original owners regardless of any intervening land sales (Leviticus 25:1–13). Our study group spent a season plowing through this and other such passages looking for insight into the whole concept of economic justice. This endeavor, however, turned out to

be an utter failure. But from that failure we confirmed something perhaps even more important about the scriptures.

In short, we could not make any real sense of the jubilee year scriptures — or any of the others for that matter. The concept of a jubilee year was interesting but impossible to carry out. It could best be described as a "thought experiment" rather than a real proposal. There is no evidence to suggest that the jubilee year redistribution of wealth actually occurred, but perhaps it did occur in some small way over a generation or two within a tightly bonded kinship group. The record keeping (not to mention the required calculations) needed to make it successful would have been nearly impossible to perform in ancient times, rendering the idea equally implausible. We simply could not formulate any actionable proposal to implement the jubilee year in ancient times. And trying to theorize a workable plan for a jubilee year in the modern world was beyond impossible.

In the modern world, what would it mean to return all land to its original owners? Let's use our corner of the world as a case study. Does this mean that all land in the United States would revert to the descendants of the original Native American tribes who roamed the lands? Perhaps. But how could this be accomplished? With the decimation of those populations and the lack of records kept by the federal government at the time, this might be a study in futility. Perhaps the land reversion could be interpreted to mean that the land would be returned to the original titleholder of European descent. Think of the exhaustive effort of tracing through generations and generations of family trees. Another question to consider is what would be done if the family of the original titleholder died out without any heirs. Who would then receive the property? And finally, if the land were to be transferred to the original titleholder or his descendants, then what would become of any mortgage on the property?

The subject of debts is a little bit easier to unravel. The only issue here is that one party's debt is another party's asset. It would be great to have your credit card, automobile, student loan, and mortgage debt cancelled. But this would then also mean that any debts owed to you would be cancelled as well. This might include any money in your bank accounts or invest-

ment accounts. These accounts are your assets but the bank's debt. Also cancelled would be any pension or life insurance owed to you.

If such debt-erasure proposals were to be truly attempted, especially on a global scale, we would see the collapse of our entire financial, banking, and economic systems as a result. Upon exploration, the jubilee year turns out to be nothing more than a fantastical thought experiment.

I stated my conclusion to the study group that we would not try to use the Bible as a science textbook, so why should we try to use it as a textbook in economic justice? The Bible was never meant to be a text on science or economic equality and justice. We will not find any help there no matter how hard we try or how deep we dig. Jesus told us some parables about workers in the vineyard and similar stories, but these parables were meant to teach small moral lessons, not to describe whole economic systems.

While the scriptures do give us some insight into human behavior, illuminate some basic concepts like human dignity, justice, and compassion, and provide a shared cultural experience, there is really very little they can tell us about our modern world and how to go about fixing the modern problems we face.

The Bible does not give us a clear understanding of topics even from biblical times. Whether the subject is baptism, the Eucharist, or jubilee years, the Bible fails to give full and complete descriptions that can be broadly accepted and used as a basis for understanding and practice in modern religion — everything is clouded and ambiguous. We need to remember that the scriptures are only a collection of stories and not a well-organized textbook or a manual of operations.

The scriptures cannot tell us how to build quantum computers, how to stop the spread of the Ebola virus, how to navigate to Pluto and beyond, or how to solve global climate change. We need to move on and think for ourselves.

CHAPTER 10
Living and Dying Without Religion

Several years ago, I was admitted to the hospital for some heart-related issues. As part of the admission process, I was asked to state a religious preference. I surprised myself by saying, "none."

For the first 61 years of my life, I participated in public acts of worship at least 50 times each year. What's more, I spent seven years in academic preparation for ministry and several more after I was ordained. 20 years of my life were spent as a pastor and regional church administrator. Religion has been a central part of my life for as long as I can remember, so why upon spontaneous questioning would I choose to claim no religious affiliation?

In recent years, I have become increasingly unhappy with the Church. Calling oneself a Christian often seems to denote a belief in ignorance, bigotry, superstition, fanaticism, and self-righteous zealotry. There was a time when there were progressive voices in the Church that stood against the dark tide of this hateful fanaticism, but those voices have grown increasingly silent. Never has it felt so embarrassing, even intellectually offensive, to call myself a Christian.

Of course, that is not to say that I am embarrassed to proclaim Jesus as Lord. Rather, I am embarrassed to be associated in any way with the Church that seems to have lost the true way of Jesus' teachings altogether. There seems to be no Christ in Christian. Those who thump the Bible the loudest seem never to have actually read it. The raw, unbridled ignorance is appalling; the arrogance is stultifying; the self-righteous zealotry is insuffer-able. As Gandhi said, "I like your Christ — I do not like your Christians. Your Christians are so unlike your Christ."[34]

The more I contemplated my decision to claim no religious affiliation at the hospital, the more secure I felt in my choice. I ran through my mental checklist and realized that there was nothing that any religion could of-fer me.

I am aware of my own mortality and health issues. I know that one day I will die, whether that death may come in 15 days or 15 years. I do not believe that I will live 20 more years and would not wish to do so unless I could be vigorous and productive. Until my death, I will live every day. And then I will die without either sadness or fear. Life is not measured by its longevity — many live long and useless lives, dying without ever having lived.

I do not need a priestly presence to utter magic incantations or perform symbolic rites or rituals over me. For all such things are simply an illusion that gives comfort to the fearful — if you die without fear, what need do you have of them? Life and death are so much bigger than these illusions.

I do not need a shoulder to cry on. In times of illness, loss, or despair, I will survive and thrive. I know how to be strong. I can find comfort without some religious illusion. Life is grand beyond measure. Even death does not dismay; there is nothing sad about death. It is the inevitable end to life. I do not need a grief counselor as there is no grief. And when it comes, death will be a remarkable experience.

I do not need to rail at the unfairness of life, for nothing in life is fair. We all have our obstacles; we all take our lumps. Someone once said, "I complained that I had no shoes, until I met a man with no feet."

And most certainly of all, I do not need a fundamentalist preacher to come and save my soul, filling my final hours with ludicrous superstition and ignorance in the process. I do not need to be manipulated into faith or be forced to make a confession. I do not need to work some arrogant preacher's checklist before I exit my life.

Those who would save other people's souls are nothing but scalp hunters who think that they have power over salvation or damnation. They think that they can work their magic with God and, in doing so, earn their own divine reward. Surely these are the most arrogant and delusional of all "Christians."

So, spare me all of this religious nonsense. Let me go from this world with a clear head and the sense of fulfillment that comes from a life well lived. I have studied science and all manner of human knowledge. I have studied the cosmos and learned of its wonders. I have read great literature and learned what it is to be human. I have travelled the world and lived abroad. I have walked and talked with my fellow travelers as we made our way on this journey of life. And I have found God in the eyes of a friend as well as the face of a stranger. My cup runneth over, and there is nothing more that I need.

CHAPTER 11
Ethics and Morality

The traditional view of Christian ethics insists that visions of hellfire are necessary to keep people in line. The goal of life is to live in a way that appeases an angry God allowing the believer to escape the fires of hell. Many of a more conservative Christian faith believe that without the overhanging threat of hell, there would be no morality at all, and we would instead be no more than animals, raping, pillaging, and murdering to our heart's content.

There are many just and righteous people of secular orientation. There are also many professing Christians whose lives do not bring honor to the Christian community. I am reminded of the scene in the movie, "The God-father," where a baptism, complete with Latin rites echoing in a sanctuary donned in religious trappings, is intercut with scenes of a slaughterous and gory mob war. The juxtaposition of these two simultaneous scenes was both brilliant and morally shocking.

Personal Piety, Guilt, and Penance

Throughout much of history, the Church has implemented guilt as a way of keeping its followers in line. The more guilt the Church can dish out, the more penitence and grace are required. This keeps believers fearfully engaged in religious practices, which in turn, keeps the Church in business. And so, the Church became the source of the "disease" as well as its "cure." It's like holding a weight loss meeting at a pancake house or an alcoholics' recovery meeting in a brewery.

The Church benefits so greatly from our guilty consciences that the construction of the Vatican was actually funded by indulgences, or sin taxes.[35] The construction of St. Peter's Basilica began in the year 1506 and was not completed until 1626. The widely accepted belief at that time was that the Church held the keys to salvation and the power of the Church was absolute. In order to be saved, people were forced to appease the Church by any means possible. This came to include the payment of indulgences for all sins, great or small.

The sale of indulgences was a corrupt system, comparable to a sordid municipality issuing citations for spitting on the sidewalk or jaywalking. When a city assesses fines and citations, not for public safety concerns, but as a way of padding city revenues, it is doing so with corrupt intent. What's worse, the poor are hurt the worst. Unable to pay a citation for spitting on the sidewalk, the poor person will be assessed further interest and penalties for nonpayment, and might even end up in jail, which further burdens them with a criminal record.

Indulgences began as "fines" assessed by the Church, and later became, in essence, licenses to sin. There was an enormous amount of money required to build the Vatican, and the Catholic Church began to use indulgences as an aggressive fundraising strategy. The funding of the Vatican's construction through indulgences became a root cause of the Protestant Reformation. The imposition of ruinous sin taxes caused a rift in the Roman Catholic Church, the core of Western European Christianity. That rift has not been healed to this day and likely never will be.

Many personal sins condemned by the Church over the centuries were never sins at all but rather expressions of true human nature. There is nothing innately "sinful" about lust, for example. Without sexual urges, the human race would have gone extinct long ago. Sexual desire is as much a part of life as breathing, but the Church has used such natural instincts to induce guilt and, with it, the imagined need for penitence.

However, there are certainly unjust actions that might be rooted in natural instincts like lust. There is sexual assault and sexual exploitation; there are actions that demean others and transform them into sex objects; there are actions that break intimate bonds and wreck families. But there is nothing innately sinful about lust itself.

The traditional Christian notion of sin seems to revolve around sex. Having an affair, being a single parent, getting a divorce, or viewing pornography are all considered to be sinful by many Christians. But one rarely hears the term "sin" applied to racism, xenophobia, homophobia, economic exploitation, voter suppression, pollution, environmental destruction, greed, or corruption. This shows how absurd our notion of sin really is. I have never heard a sermon proclaim that fraudulent business practices are a sin. To be fair, I have preached that sermon, but I still have not heard this from anyone else.

Jesus never actually mentioned sex in the Gospels. Jesus did, however, spend a lot of time talking about unclean foods and eating with unclean people. In Jesus' day, eating with a stranger was the most intimate thing you could do. To eat (ritually) unclean foods, or to eat with (ritually) unclean people, were two of the most sinful and self-polluting things possible. It is then remarkable that the ultimate expression of Christian community is the sharing of the Lord's Supper.

Throughout history, the Church has committed seemingly endless crimes against humanity. Jesus commanded that one must remove the log from his own eye before trying to remove the speck from his brother's eye (Luke 6:41–42); this is a principle that the Church desperately needs to heed.

Sex Abuse and Cover-Up

To find an example of the Church's crimes, one need only look at the ongoing global scandal of child sexual abuse in the Catholic Church. It is unthinkable that a celibate clergy has the gall to pontificate on all sorts of moral, sexual, and reproductive issues, all the while subjecting young children in their spiritual charge to sexual abuse. And to make matters worse, the bishops have responded not by purging this gangrene from the Church, but by covering it up in order to protect the Church's "reputation."[36] While reform efforts have been made over the past few decades, not nearly enough has been done to heal old wounds or to protect today's children from continual abuse. In 2011, the Republic of Ireland broke diplomatic relations with the Holy See (i.e. the Vatican) over the issue of child sex abuse by Catholic Priests.[37]

Nazi Germany

Germany was — and in many ways still is — the intellectual and academic capital of Christianity. Since at least the time of Martin Luther, Germany has been the center of Christian theology and biblical scholarship. Like many others, I studied Greek and German during my undergraduate studies in preparation for seminary. I wanted to read the New Testament in its original language and study theology and biblical scholarship from the German masters. The great German theologians of the 20th century included such names as Jurgen Moltmann, Wolfhart Pannenberg, Gerhard von Rad, Albert Schweitzer, Dietrich Bonhoeffer, and Paul Tillich.

How, then, could such a country give birth to Nazism and all of its horrors? What part of Christianity did the German theologians not understand? And, why did the vast majority of German Christians go along with the Nazi horrors?

Only a small remnant of the Church remained faithful. This remnant was the Confessing Church under the leadership of Dietrich Bonhoeffer.[38]

Colonialism

The voyages of Christopher Columbus launched an age of exploration and colonization. Under Christian Europe, Spain, Portugal, England, France, Belgium, and the Netherlands began a global colonization effort. These nations believed that God had given them dominion over the entire Earth, and any non-Christian populations were heretical and there only to be exploited and converted to Christianity. The Christian nations went into the world, raping, pillaging, plundering, enslaving, and destroying everything they came across. Based on Christian colonial thinking, native peoples did not "own" their lands because they were not part of Christendom. They were no better than animals to be harvested or conscripted for labor. Christianity was spread from Europe throughout much of the world by cross and sword.

Along the way, the Christians destroyed the native languages, libraries, artwork, and much evidence of the greatness of these cultures. Native cultures were feared as "heathen" and destroyed.

In a similar fashion, Islamic militants have destroyed buildings, artwork, libraries, and other artifacts from the ancient Middle Eastern civilizations, some up to 10,000 years old, because they considered them to be an insult to Islam. Such a loss has been a devastating blow to our human cultural heritage.

"Missions" is such a lovely word for what were essentially slave plantations run by the Catholic Church in California. Junípero Serra is considered to be the founder of the California missions. Serra was also an official inquisitor of the Spanish Inquisition.[39] He had dictatorial powers throughout his territory to purge witchcraft or any religious practices deemed non-compliant with Catholic doctrine. Serra brutalized and enslaved people, destroying their culture in the process. The converted natives were held captive in what can only be described as concentration camps and forced to perform slave labor. They were not allowed to communicate with their unconverted families or friends because Serra feared that they would be contaminated by any further contact with the "heathens." There was much opposition to

Junípero Serra's canonization, but he was sainted by Pope Francis in 2015, nevertheless.

In summary, if you are looking for moral authority within the Christian Church, you'll be hard-pressed to find any. The Church's long history of egregious moral misbehavior and religious zealotry has been a destructive counterforce to any good the organization has done.

One could well argue that the Church has had an overall negative effect on ethics and morals through history. Despite the lofty moral values proclaimed by the Church, religious supremacy in all of its attendant evils has done great damage to both individuals and peoples, raising the question of whether they are a standard for good at all.

Source of Ethics and Morality

The question is then, where is our source of ethical and moral guidance? To many secular people, along with many enlightened spiritual leaders of many traditions, ethics and morality begin with the respect for other people. It is *do unto others as you would have them do to you*. It is *love one another because love is from God*.

Morality is not about adherence to religious doctrines or constructs; it is not about personal piety; it is not about church attendance, fulfilling all religious obligations, or converting others to your religion, with or without the use of force; it is not about appeasing an angry God so as to avoid the fires of hell.

Morality is about living in community with others. True morality is not personal but social and political. Other people are vital members of our family, clan, tribe, nation, and planet. One does not rejoice that the other end of the lifeboat is sinking because we are all in this together.

Morality is about saving the planet; it is our habitat and our future. We are partnered with not only our present brothers and sisters, but with future

generations as well. We do not inherit the Earth from our ancestors; we borrow it from our descendants.

Morality is about meeting the needs of all. The hungry child of a Syrian refugee should concern us as much as the Honduran child locked in a cage at our southern border, and the child of a single mother down the street who must work three minimum wage jobs to survive.

Every issue in today's world has global repercussions. Consider refugees, diseases, pollution, terrorism, habitat destruction, global climate change, clean water, and energy. All of these may start as local issues, but the solutions must be global. Pollution does not stop at national boundaries. The Ebola virus can jump borders instantaneously. Deforestation spans continents.

Morality means being part of a global village, where ancient tribal boundaries, ethnic and religious divisions, have been forgotten. Morality means working together for the benefit of all.

Morality in business means considering the welfare of all stakeholders and not just the stockholders. Morality in business means finding a balance of interests. Business deals should be made based on long-term relationships of mutual advantage between and among the various parties.

Big Pharma is letting people die due to outrageous and unfair drug prices in order to increase the return on investment to the shareholders. Such practices are immoral and sinful. But this is one of the many types of sin about which the Church is strangely silent.

Voter suppression, election rigging, and gerrymandering are all sinful. Fraudulent or even deceptive business practices are sinful. Polluting the planet for short-term corporate gain is sinful. Political corruption is sinful. And yet the supposed pinnacle of morality, the Church, is silent.

CHAPTER 12
Prayer and Spirituality

We become what we envision. Where our minds dwell determines where our life will lead us. Our mental hygiene is every bit as important as bathing and brushing our teeth. Our moods, our composure or lack thereof, and even our personality, are determined by brain chemistry. This notion was first presented by Peter D. Kramer in "Listening to Prozac." There are two ways to manipulate brain chemistry: external chemical intervention and internal mental hygiene. External chemicals and internal mental hygiene interact with each other, controlling brain chemistry and thus determining our emotional state, level of composure, and even our personality.

In 12 step programs, people talk about "stinking thinking," which can quickly lead people to ruination. For example, an alcoholic may think that she is no longer an alcoholic and so buys some beer as a test. But she cannot buy just one beer, but instead will buy a case of 24. This is "stinking thinking." For the addict, sobriety is primarily the effective maintenance of mental hygiene.

There are so many voices inside of our heads, some helpful and some destructive. These voices are a part of who we are and can never be silenced or

eliminated. In the same manner that we cannot "purge" a family member, no matter how difficult or deranged, we cannot purge these disturbing voices because they are a part of us, whether we like it or not. But some of the voices cannot be allowed to take control. This is what it means to be "in our right minds."

Imagine the voices in your mind as people on a bus. While there are many people on the bus, there are some that should never be allowed to drive. Let those discordant voices sit in the back of the bus and mumble until they fade from your conscience. Pay attention to the positive voices that are edifying and uplifting, and soon the discordant voices will fall silent. Let those voices drive the bus.

As we focus on the positive voices, we are led in a positive direction. When our minds are full of love and compassion, we become loving and compassionate. Likewise, if we focus on negativity, our lives will naturally take that direction. For example, if someone focuses on racial hatred, they are bound to become a hateful racist and perhaps even act upon their hatred by violent means. If someone fills their mind with the influences of violent and dehumanizing pornography, they will likely become a pervert and might even act out those perverse instincts.

Prayer and meditation are excellent ways to manage mental hygiene. These practices focus positive energy on the broken places, directing our feet down paths of wellness. Prayer should be viewed as a method of centering and focusing our minds. It is a time to expand our consciousness and activate the most benevolent parts of our true selves.

Prayer does not change God, but it does change us. Pope Francis said, "Pray for the hungry, and then feed them. That is how prayer works."[40]

Our lives are the product of the choices that we make. We need to step out of our daily existence and map our selected journey; otherwise we wander aimlessly, reacting to every stimulus that we encounter. Prayer can give us that transcendent experience to see beyond our immediate needs and to focus on our ultimate goal.

CHAPTER 13

The Scientific Mindset

The scientific method is the only real way to test our beliefs and assertions. Too many people believe too many things that simply are not true because they choose to blindly trust rather than put their faith in reality. If we want to separate fact from falsehood, we must use methods developed by science to test and validate.

Science is radically self-correcting. If one scientist publishes a paper, there will be hundreds of others who will pick apart everything about her original experiment. Is the math correct? Are the data valid? Are the results statistically significant? Was the testing equipment precise enough for the test? Did the equipment work correctly? Are there outliers in the data that would invalidate the conclusions? The review process is aggressive and merciless because it has to be. If the new conclusions pass the strenuous review process, the results of the test are accepted into the growing body of scientific knowledge.

Science allows us to cure diseases and send spacecraft to Pluto and beyond. It allows us to create green energy systems that will eventually bring the

burning of fossil fuels to an end. Science brought us mobile phones that surpass the capabilities of the computer that first sent man to the moon.

Modern medicine arguably began in Baltimore, Maryland at Johns Hopkins University in 1900.[41] The Baltimore medical revolution involved the dissection of corpses, research, experimentation, and careful documentation of the progress being made. The impetus for this great advance came from the appalling casualties of the American Civil War. Before 1900, there was no medicine truly worthy of the name. When President Abraham Lincoln was shot at Ford's Theater, his doctors made some very serious errors that may very well have cost him his life. First, they bled him because at that time blood was considered impure. In those days, the way to treat a bleeding, wounded person was to drain even more of the "impure" blood from the victim than they were already losing. Secondly, Lincoln's surgeon poked around in Lincoln's brain with what was essentially a knitting needle in search of the bullet, completely unaware and unbothered by the potential damage he caused in the process.

Further exemplifying the lack of medicinal authenticity, snake oil salesmen were common in 19th century America. Traveling "doctors" of dubious credentials traversed the country, selling useless and often harmful elixirs.[42] This practice was first regulated by the Pure Food and Drug Act passed in 1906.

The term "snake oil" actually comes from an ointment used in traditional Chinese medicine that used the fat from the Chinese water snake. Traditional Chinese medicine dates back over 2,500 years, but even to this day it is highly controversial.[43]

While many people support it and laud its properties, to the practice's critics, it is more malarkey than medicine. Traditional Chinese medicine makes use of mystical elements that have not been scientifically validated, such as *chi (or qi)* energy, acupressure points, and meridians on the body. Modern medicine has been almost entirely unsuccessful in formulating useful treatments from ancient herbal recipes. What's more, ingredients in

traditional Chinese medicinal remedies often require the harvesting of elements from endangered species, such as rhinoceros horns and tiger bones.

For these reasons, traditional Chinese medicine often falls in the category of illusion. There are only two assumptions we can make about this style of "medical treatment."

One assumption would be that traditional Chinese medicine is simply based on undiscovered science. Perhaps there are acupressure points that have significant impact upon bodily function and doctors just haven't properly researched the potential. If this is true, we should be able to identify these points based not on mysticism, but on the underlying physiology of the body. And likewise, a portion of the various recommended herbal remedies may, in fact, be effective, but the only way to substantiate this would be through rigorous trials and testing using the scientific method.

The alternate and much more plausible assumption would have to be that most or all of the system of traditional Chinese medicine is simply an illusion based upon traditional cultural practices, mysticism, and folklore, if not also a bit of placebo effect. For example, rhinoceros horn is used in traditional Chinese medical to treat erectile dysfunction.[44] However, rhinoceros horn is made of keratin, which is the same substance found in our hair and nails, as well as the hooves, beaks, and claws of most animals, so where is the need to specifically use the endangered animal's keratin? Why not use cattle hooves, or better yet, a bio manufactured synthetic?[45] A cynic might suggest that rhinoceros horn is used because rhinoceros horns stand erect.

The scientific method is how we test and validate all of our assumptions. When we fail to do this, we live in ignorance believing the illusion of folklore and superstition. While ancient tradition may be comforting, it is not likely to be the most helpful approach to everyday life.

The scientific mindset is based on two traits: skepticism and open-mindedness. Skepticism causes us to challenge assumptions, even those that may be long-standing. Open-mindedness requires us to embrace new ideas.

Scientific discovery is an ongoing process. For instance, even with the great advances made by Isaac Newton and Albert Einstein, we still do not know everything about gravity. We only recently discovered gravity waves for the first time in history. We are still looking for the expected graviton particle that many physicists believe is the carrier of gravitational force. We do not know yet how gravity relates to the other three physical forces — electro-magnetism, the strong force, and the weak force. We do not know how gravity relates to dark energy, a mysterious force that causes the universe to expand at an ever-increasing rate in what could essentially be described as the opposite of gravity.

Every new discovery in science leads to new questions. Science is not a museum of validated discoveries. It is more like a field trip pushing the frontiers of knowledge. It will continue to be an open-ended inquiry for as long as we can envision. This is why it is important to approach everything with a scientific mindset — to prevent the pitfalls of illusion.

CHAPTER 14

Religious Freedom

I am a strong advocate of religious freedom. I believe that all people should have the right to pursue their own religious course in life or choose none at all. I do not hold my personal Christian faith journey as superior in any way to that of those around me.

No religious organizations or leaders have any overt control over you; their control comes only when you surrender your power to them. Of course, they do not want you to know this because it threatens their hold on you. Religious organizations want to control your thinking, your behavior, your loyalty, your beliefs, your service, and your treasure — you do not have to let them.

In America, you are a person free to pursue your own faith journey. Should you wish to worship Charlie Brown's Great Pumpkin or the Force from the Star Wars universe, you are legally free to do so as long as you do no actual harm to others in the process. And it is important to differentiate between harm as defined by public safety and that which might qualify under doctrinal issues. Actual harm would come from such things as using metham-

phetamines in your liturgies, handling poisonous snakes as a proof of faith, molesting children, spreading hatred, or practicing human sacrifice.

However, while the legality of it is not in question, I would personally advise you not to pursue a faith journey that is trivial and unworthy of your best efforts. There is tic-tac-toe, and then there is chess. A faith journey is not some form of mild amusement, but a source of focus, meaning, and purpose for your life. A faith journey should be something worthy of your devotion.

The United States of America is not, and never has been, a "Christian" nation. Rather, it is a secular nation with the guarantee of religious freedom to all. After centuries of religious warfare, persecutions, and strife in Europe, this nation was designed as a haven for all, regardless of their religious views or affiliations. Under the Constitution, there can be no establishment of religion by the government and no religious test for citizenship or election to public office.

In an April 11, 1823 letter to John Adams, Thomas Jefferson wrote:

> The day will come when the mystical generation of Jesus, by the supreme being as his father in the womb of a virgin will be classed with the fable of the generation of Minerva in the brain of Jupiter. But we may hope that the dawn of reason and freedom of thought in these United States will do away with all this artificial scaffolding...[46]

In the midst of our current political polarization, even the concept of religious freedom has lost its meaning. Despite the stigma it has garnered, religious freedom does not give you the right to discriminate against others who may not share your religious views. Religious freedom means that we all share a guarantee of equal religious protection under both the First and Fourteenth Amendments of the Constitution.

However, what the religious right interprets this amendment to mean is that anyone, but mainly a fundamentalist Christian, is allowed to express

his or her religious views at any time and place, regardless of the effect that such an expression might have on the freedom of others.

In modern American political life, the concept of freedom of religion as guaranteed under the First Amendment has become distorted to the extreme. Kim Davis, the former County Clerk of Rowan County, Kentucky, tried to exercise her "religious freedom" by denying a marriage license to a gay couple, because she *believed* doing so violated her religious conscience and infringed upon her right to religious freedom. The problem was, however, that gay marriage was the law of the land and doing her job as county clerk did no actual harm to her.[47]

Using that same logic, a white supremacist fire chief could refuse to extinguish a fire at an African American family's home; a Jehovah's Witness doctor could refuse to go through with a lifesaving blood transfusion; a fundamentalist judge could fire any female employee for having a baby out of wedlock; a government-run adoption agency could deny a family an adoption because they follow Islam. And all of these decisions would violate the law of the land as well as justice and common decency, but follow Kim Davis' line of "religious freedom" logic. Simply put, the religious convictions of various government employees cannot legally sway the performance of their official duties.

Since Kim Davis refused to do her lawful duties based on her personal religious convictions, she should have been summarily dismissed from office. She, and everyone else, has the right to their own beliefs, but as a government official, she is required to perform her governmental duties as an impartial agent of the Constitution. The government and its agents must serve us all equally and fairly, their religious predispositions notwithstanding.

Furthermore, personal religious beliefs do not give anyone license to violate the civil rights of others. During the 1960s Civil Rights movement, it was determined that the lunch counters must be open to all people regardless of race. A similar battle is now being fought in the 2010s about bakers and florists refusing service to LGBTQ wedding customers.[48] The rule should

be very simple: public businesses have no right to deny service to anyone based on personal religious prejudices.

When a courthouse or other public venue displays religious artifacts such as a copy of the Ten Commandments, it is a flagrant establishment of religion in our purportedly secular democracy and an egregious injustice to all protected by the Constitution. It is simply impossible for the government to embrace both the First Commandment, "You shall have no other gods before me," and the First Amendment, "Congress shall make no law respecting an establishment of religion."

The Ten Commandments is a cultic document — pure and simple. Admittedly, it does contain some rules of civic virtue like you shall not kill, you shall not steal, and you shall not bear false witness. But the main thrust of the document is cultic, demanding a total submission to the God of Israel.

As a practical matter, the display of the Ten Commandments in a governmental setting has been a serious injustice to those of other faiths. Suppose a Buddhist is called before the court. The judge or jury might erroneously assume that the Buddhist was an "idol worshipper" and undeserving of justice in a "Christian" court. In truth, Buddhists do not worship idols any more than Catholics worship candles. But the damage has already been done by the prejudicial presence of the Ten Commandments monument on the courthouse grounds.

Currently, the abortion controversy is the pinnacle of this debate. The religious right insists that abortion is a sin and should thus be outlawed. But the separation that supposedly exists between church and state means that an act's sinful nature is not pertinent to its legality. Who ever said priests, preachers, and right-wing politicians should have dominion over women's bodies? These decisions should be left to the woman and her doctor.

The false notion that life begins at conception has no mention in the Bible. So, while touting the authority of scriptures, anti-abortionists are effectively trying to force others to accept a religious belief system that is not at all biblical. Indeed, what the Bible says is that life begins at first breath. In

Greek, *pneuma* means both breath and spirit. In Hebrew, *ruach* has much the same meaning. With our first breath, we "inspire" (are filled with the spirit/breath), and at our death we "expire" (the spirit/breath leaves our body).[49]

An alternate concept for the beginning of life in the Bible is the time of "quickening," or the time when the baby first begins to kick and move so that the mother can feel its presence. This notion of quickening signifying the beginning of life is also found in the Nicene Creed (from the Council of Nicaea in the year 325), which contains the phrase, "...from thence he will come to judge the quick and the dead."

The battle over abortion and birth control is spawned of the religious right's need for control. They want to assign personhood to the fertilized egg, giving the embryo more rights than the woman who is carrying it. As a result, women are viewed by the religious right as walking incubators that must be forced to carry every pregnancy to term despite their medical condition, family situation, or other circumstances. But regardless of the politics of the abortion debate, the religious viewpoints of either side should never come into play, as it is a matter of law, which is theoretically protected from religious interference.

Religious freedom means the right to worship, pray, and believe as one chooses, or not at all. Religious freedom does not give anyone the right to impose their views on anyone else as so many seem to interpret it. Religious freedom is not only freedom *of* religion but also freedom *from* everyone else's religion.

CHAPTER 15
Benefits of Religious Participation

M any have found that participation in a religion is a source of comfort and strength. These benefits can come from any number of sources within the religion.

Community

A religious community can be a great place to find people of similar interests and values. There are religious communities of all brands and types, so most people should be able to find a compatible group. The major exception might be in remote areas where choices are limited. But even still, within the smallest group, differing opinions offer opportunities for discourse and companionship.

A religious community is gathered for noble purposes and values. Because of this, it should be a safe place for companionship, growth, and mutual sharing. But of course, nothing is certain, so it is always wise to be wary — a group is made of individuals, after all.

A community of any sort, especially one joined by religious devotion, should function as an extended family, where the well-being of each individual is a primary concern. There should be help available in a crisis, and this help should be free of cost and readily available. This is especially true in terms of a major health issue or the loss of a loved one.

A community is also a venue for joint action. It is hard to feed the homeless alone, but people working in groups toward the same end may succeed where individual efforts might fail. In undertaking hard tasks, comradery is an essential element. Bonds are forged with other individuals when we share common goals and tasks.

Transcendence

Worship is the core of any religious community. In worship, there should be a sense of transcendence that lifts us out of our mundane lives and connects us to a spiritual plane much larger than ourselves. This experience can be profound and life-changing. Our focus shifts from our own comforts and survival to a broader view of the world. We are filled with the joy that comes from participation and connection. Worship gives us the strength and power to cleanse our innermost thoughts and improve our mental hygiene so that we can focus on how to be our best selves. We shed the worries of our daily lives and find our inner resources that make our mundane difficulties seem trivial.

Rhythm and Ritual

As biological creatures, nothing is more comforting to us than rhythm and rituals. Our lives are directed by circadian rhythms. Generally speaking, we want to sleep at the same time every night and eat breakfast at the same time every morning. We want to feel in sync with daily, weekly, monthly, and annual rhythms as we cycle through various periods of time. We thrive on regular cycles and feel in tune with the natural world. Holidays help us mark the seasons as we cycle through the year, and religious services offer ritual and routine to our week.

Artistic Beauty

Worship should be clothed in beauty. Beautiful music stirs our souls, and touches us in places where the spoken word can never reach; festive banners and decoration of good design and construction add color, drama, and pageantry to worship; architecture lifts the spirit and shows us a world beyond the ordinary; flowers bring color and life to the service.

The great Gothic cathedrals of Europe have been described as symphonies in stone. One of the greatest spiritual experiences is to sit in a cathedral of stone while the pipe organ plays. You not only hear the music, but feel it rumbling through every cell of your body as if it were the lifeblood of religion itself coursing through your veins.

Spiritual Values

Your faith community experience should center on spiritual values that function as a compass for your life. Many addicts have found comfort and support in their spiritual communities that enabled them to finally manage their addictions. The support of the community, along with the displacement of addictions by the spiritual values of the community, have brought health and wholeness to many.

Spirituality helps with our mental hygiene. Worship is a time to stop and reflect on our life, our inner state of being, the way we have treated others, and our deepest longing and desires. It is a time to reinforce our most positive energies and to silence those disturbing voices within.

Make sure that your faith is worth living. Choose a faith that is worth your full conviction. Do not waste your time on trivial or even destructive pursuits; rather pursue a faith journey that is positive, uplifting, compelling, and fruitful.

CHAPTER 16
The Neighborhood Church

The representative neighborhood church is under severe and increasing stress. Church attendance and membership have been declining since the mid-1950s with no reversal in sight.[50] The United States is following Europe into a post-Christian era.

At present, 53 percent of Americans say that they attend church seldomly or never.[51] And the actual number might be even more dismal. In many studies, when people self-report their church attendance, they claim much higher attendance than records kept by churches indicate. Obviously, people are reporting what they believe they ought to be doing rather than what they actually do.

It is difficult to compile church attendance statistics across denominations, as the methods used by differing denominations will not be consistent. For example, Catholic churches count families instead of individual members. What's more, there may be significant biases in the data as denominations may try to artificially increase their results when compared to "competing" denominations.

To begin examining this, let's use some basic statistics from my denomination, the Presbyterian Church (USA), as a case study.[52]

The Presbyterian Church was one of the most preeminent churches in America in the colonial days. Its first American congregation was founded in 1640 in Southampton, Long Island. Princeton University was founded in 1746 as a college for Presbyterian pastors.[53] Today, however, the power and influence of the Presbyterian Church is waning, as is the case with many of the old, "mainline" churches. Today, the Presbyterian Church reports 1,352,678 members as of the end of 2018.[54] There were 9,161 congregations in the Presbyterian Church at the end of 2018.

The following table shows the distribution of these congregations by size:[55]

2018 PC (USA) MEMBERSHIP	NUMBER OF CONGREGATIONS	PERCENT OF TOTAL CONGREGATIONS
0-49	3,375	37%
50-99	2,193	24%
Under 100	**5,568**	**61%**
100-149	1,207	13%
150-299	1,339	15%
100 to 299	**2,546**	**28%**
300-599	691	8%
600-999	218	2%
1000-1500	81	1%
1501+	57	1%
300 and More	**1047**	**11%**
TOTAL	**9,161**	**100%**

Before we begin analyzing these statistics, I would like to offer a few comments based on my experience as a pastor and regional church administrator. It is very hard for small churches to survive. I would call a small church anything under 300 members, and a very small, or micro-church, is anything under 100 members; their very existence is precarious at best.

It is also important to keep in mind that membership numbers are not the best indicator of a congregation's strength and viability. Far more import-

ant is the average number of weekly worshippers. I was recently a part of a small congregation in a small town that had 140 people on the rolls but, on average, only had about 35 worshippers attending service each week. Many of the 140 listed members had not been seen in church for years, while others only came on Christmas and Easter. What's more, upon inspection, I noticed that a large number of the town's merchants were listed as members even though only one of these was an active participant in the church. A cynic might suggest that the rest had "joined" the church only for the chance of free advertising in the church directory.

As a general rule, when evaluating the size of a church, one should consider only one-half of the church membership as active participants in the mission, worship, work, and financial support of the congregation. Bearing this in mind, the statistics as listed above are even more dismal.

Of the 9,161 congregations in the Presbyterian Church, 61 percent have fewer than 100 members and 89 percent have fewer than 300. These figures do not bode well for the survival of these congregations or the denomination as a whole.

Using these statistics, let's build a profile of a typical 100-member congregation. Based on Presbyterian Church (USA) statistics, in 2017, the average member contributed $1,162 to the church. So with 100 members contributing $1,162 each, the annual contributions for this hypothetical neighborhood church would be $116,200.[56]

The typical Presbyterian congregation desires a full-time, resident, seminary-trained pastor. In many cases, this has become more than the congregation can afford. As a minimum, a Presbyterian pastor must have an accredited Bachelor's degree plus a three- to four-year graduate degree (Master of Divinity) from an accredited seminary.

Based on my experiences, the following represents what I believe is a reasonable financial profile for a small congregation. The minimum cost for this qualified pastor is around $70,000 per year in salary, benefits, and re-

imbursement of professional expenses — and there goes 60 percent of our hypothetical congregation's budget.

There are alternatives, however, for pastoral staffing. Some pastors are part-time, which is to say that they often work full-time while being paid part-time. There are also yoked churches that share pastors, but this is severely limiting because of distance factors. If there are two small, yoked churches in the same vicinity, it usually makes more sense to merge the two churches rather than share pastors. And finally, there are lay pastors who lack seminary training but serve in pastoral roles, especially within micro-churches.

Churches typically require more staffing than just the pastor, though. It is common to have an office manager, custodian, organist, and choir director, as well. Most of these positions are part-time, but they still increase the church's total staffing costs.

The next biggest expense category is occupancy costs, which include rent or mortgage, utilities, insurance, maintenance and repairs, capital improvements, and groundskeeping.

It is easy to see how small congregations can struggle to survive financially. After staffing and occupancy costs comes the cost of supplies; this includes office supplies, cleaning supplies, church school curriculum and supplies, and worship supplies such as choir music and holiday decorations. No one wants to see a church run on pirated software or the choir using photocopied sheet music to avoid having to pay royalties.

And finally, after staffing costs, occupancy costs, and supplies, the congregation will spend the tiny amount left on mission beyond its walls.

Another factor affecting churches is neighborhood transition. While our nation as a whole grows more racially diverse, many more traditional churches do not reflect that diversity. It is hard for predominately white congregations to attract people of color. The Presbyterian Church's strategy for dealing with diversity has been to establish separate congregations for the various racial/ethnic groups. In most cases, attempts to integrate people

of color into existing predominantly white congregations have not been successful for various reasons.

Finally, another serious threat to the neighborhood church looms: an aging membership. It is common to see a lot of people with grey hair sitting in church. In many congregations I have known, the "young" members were in their 50s and 60s while the "old" members were in their 70s and 80s. Such demographics make it very difficult to attract truly young families with children. Families want to see a high-quality Christian education program for children and youth groups for adolescents. They also want to have other people their age that they can relate to. They will rarely find these components at a church with an aging congregation.

Once, in my role as a regional church administrator, I visited a church in Oakland, California that had a small congregation of aging white people set in a transitioning neighborhood. The building was suitable for a congregation of 600 or more, but the congregation had dwindled to fewer than 100. When touring the building, I noted that the church had a great gymnasium, however, the congregational leaders pointedly corrected me, insisting that it was *not* a gymnasium because they had taken down the basketball hoops. It turned out that the church had been "forced" to take down the basketball hoops because neighborhood kids were breaking in to play basketball. Talk about a missed opportunity. Even if the church hadn't the resources to run a basketball program, it might have made an arrangement with the YMCA, Boys and Girls Club, or similar organization to provide a program for the neighborhood youth who might have eventually revived the dwindling congregation's numbers.

CHAPTER 17

Megachurches and Televangelism

In the beginning the church was a fellowship of men and women centering on the living Christ. Then the church moved to Greece, where it became a philosophy. Then it moved to Rome, where it became an institution. Next it moved to Europe where it became a culture, and, finally, it moved to America where it became an enterprise.

— Dr. Richard C. Halverson[57]

Personally, I have never considered either televangelism or megachurches to be legitimate churches. Rather, I would consider these to be new religious forms of showbiz. However, as this book is an exploration of the whole religious landscape, and many people do consider televangelism and megachurches to be religious phenomena, I think it's best to include these in my examination of the concept of religion.

Megachurches

Once while attending a seminar on church finances, a vendor selling church software offered the group some free tickets to a local megachurch's Christ-

mas pageant that would take place in a few days. They described how the highlight of this Christmas pageant was how there would be actors dressed as angels flying across the sanctuary on hidden wires. The vendors stressed how expensive and hard to get these tickets were. No one in the seminar was interested in the tickets and the vendors could not understand why. Since when has worship transformed into a Las Vegas show? What does a humble birth in a manger have to do with paid actors portraying angels on a wire? What would Jesus think?

Our whole culture is obsessed with entertainment. Megachurches are what happens when religion buys into this cultural obsession and allows itself to become no more than another form of entertainment. Megachurch worship can be a dizzying experience. Simultaneous multimedia presentations are common. I once visited a megachurch and was astonished at the complexity of it all. There was a gospel music video playing on one screen, which was accompanied by live dancers on an adjoining stage. On another screen there was an aerial video presentation of beautiful mountain scenery. Meanwhile, the pastor prayed for individuals in the orchestra pit. It was truly like watching a three-ring circus.

The dazzling showmanship often obscured the message, which I found to be theologically repugnant. It is often very easy to insert dark theology while people are distracted by the entertainment. With the bright lights and twinkling music, it could seem like a safe place with a positive message, but that was certainly not the case with this specific church, and as I suspect, many other megachurches. Some of the messages I heard at this megachurch were:

- The scriptures are the only rulebook required for righteous living.

- Anyone not saved by Jesus will burn in hell, including those of other faith traditions.

- The church needed to take over the local school board in order to replace science with Bible stories in the school curriculum.

- A woman with a life-threatening pregnancy would be better off dead than to live as a murdering abortionist.

Megachurches can be quite entertaining. Their worship services can provide a dazzling experience. In comparison to the megachurches, the worship at a neighborhood church can feel quite shabby and impoverished. It would be impossible for the typical small church to compete in worship with the megachurches. This would be like a non-profit community theater trying to compete with a Hollywood blockbuster or a Broadway production.

Personally, I would not want to attend a local church that tried to compete with the megachurches. The neighborhood church would need to "sell its soul" to become an entertainment venue. I would prefer to spend my time with other disciples in a community of faith, regardless of how small or impoverished.

Televangelism

Before I demonize the construct of televangelism, I would like to share the name of one televangelist whom I believe is apart from the rest. Rick Warren preaches a message that is worth listening to and proclaims a faith that is worth living. He has written some amazing books such as "The Purpose Driven Life." Warren is also very authentic in his ministry. He, unlike almost all of the other televangelists, is not in it for the money. Because of the great financial success of his books, he gives away 90 percent of his income to good causes.[58] While I cannot agree with Warren's fundamentalist theology, I admire him greatly for his faithfulness, his integrity, and his sense of discipleship. Warren is, I believe, simply the only televangelist who actually teaches true discipleship — others only entertain. Still others promise wealth and blessing in return for big contributions to their ministries.

To understand televangelists, one need only look at Jim and Tammy Faye Bakker. Jim and Tammy Faye were known for their extravagant lifestyle and opulent spending habits. The PTL Club was their weekly television series, and at the height of its success, the Bakkers were raking in contributions at the rate of $1 million per week.

Financial and sexual assault scandals ended their televangelist reign, but only temporarily.

- In 1979, the Bakkers allegedly raised $350,000 for overseas mission. But instead, the money was used to enhance their amusement park, Heritage USA, and some was syphoned off for personal use.

- In 1985, an IRS report showed that the Bakkers diverted $1.3 million from the PTL Club for their personal use. The report sought that the tax-exempt status of the PTL Club be revoked, but nothing was done because the Reagan administration did not want to offend its evangelical supporters.

- In 1987, Bakker paid hush money to his secretary, Jessica Hahn, who accused him of drugging and raping her.

- From 1984 to 1987, the Bakkers sold tens of thousands of timeshares to their viewers. Each timeshare entitled the holder to a three-night stay at a luxury hotel at Heritage USA every year for the rest of their lives. Only 500 timeshare hotel rooms were built. The result was a massive real estate fraud.

Jim Bakker was sent to prison for his crimes, but upon his release he returned to the televangelism business where he remains to this day.[59]

While it's true that not all televangelists are criminals, it can be argued that most are likely in it only for the money. They live in multimillion-dollar mansions and fly in their own private jets. They are raking in countless millions of dollars each year.[60]

Kenneth Copeland has said in the past that he needs his own private jet because God does not speak to him when he flies first class. Also, Copeland claims that there are demons on first class flights that he tries to avoid.[61]

Joel Osteen at first refused to open his Houston megachurch to aid the victims of Hurricane Harvey in August 2017. Instead, he offered prayers and

little else. Osteen's Lakewood Church is the former arena for the Houston Rockets NBA team and seats 16,000 people. Osteen only later opened the church to hurricane victims after extensive public criticism.[62]

Below is a list of the richest televangelists in the United States according to the latest estimates. There are different estimates of the net worth of these and other televangelists. While the details may vary somewhat between these various sources, the overall results are comparable.[63]

TELEVANGELIST	NET WORTH (MILLIONS)
Kenneth Copeland	$ 760
Pat Robertson	$ 100
Benny Hinn	$ 42
Joel Osteen	$ 40
Creflo Dollar	$ 27
Franklin Graham	$ 25
Rick Warren	$ 25
T.D. Jakes	$ 18
Joyce Meyer	$ 8

The amount of money contributed to these televangelists is beyond staggering. It is hard to believe that anyone could be convinced that Kenneth Copeland needs your "seed money" to do the Lord's work when he is worth $760 million. It is even harder to understand why these ministries should be tax exempt. The need for such extravagance to promote God's mission on Earth is even more unbelievable and astonishing when you compare it to the $116,000 budget of the typical neighborhood church as outlined in the previous chapter.

Watching a televangelist on TV and contributing to their faith fund is not the same thing as participating in a faith community. These televangelists will not visit you in the hospital, or help you through a family crisis. If you need help or support from these organizations, the best you can hope for is a telephone prayer from one of their thousands of staffers. And of course, you will need to make a significant donation to get this prayer.

Other than Rick Warren, most televangelists preach what is called the "prosperity gospel." Key proponents include Benny Hinn[64] and Joel Osteen.[65] The prosperity gospel is a consumer-oriented version of Christianity that promises a shower of blessings to its adherents with little demand for discipleship, spiritual growth, or service to others. But before we begin examining the prosperity gospel, let's first take a look at a similar concept: the infamous "Nigerian Scam."[66]

The Nigerian Scam begins with an email, allegedly from a deposed Nigerian prince. He wants to send you tens of millions of dollars for "safekeeping," but first you must pay him a slight fee, let's say $1,000, to cover wire transfer fees or perhaps "earnest money" to show that you are sincere and trustworthy. The scammer wants a wire transfer so that he can establish a direct link to your bank account. We all know how these scams go.

But the less familiar scam of televangelist seed money operates in an extremely similar fashion. The prosperity gospel televangelists will tell you that God wants to shower you with blessings, but in order for God to do this, you must first pay some earnest money to the televangelist. You must sow seeds of tithes to the televangelist, which will then compound and benefit you in the future. Once your seed money has been sown, God will not only send great wealth your way, but also health, contentment, esteem, and anything else your heart desires. Jim Bakker went to prison for selling timeshares he was unable to deliver. But the current flock of televangelists is wiser — they do not make the foolish mistake of promising traceable tangibles like timeshares. Rather, their promises are vague enough so as to escape any legal liability. And, if your blessings do not arrive, the televangelists can blame you for your lack of commitment.

It is understandable how other Hollywood celebrities become rich and famous. We love our movie stars, musicians, and athletes. We will shower them with money because they entertain us immensely. But *ministry* is not meant to entertain us; ministry is supposed to be about discipleship, spirituality, reverence, scholarship, sacrifice, and service. Ministry is not — and must not ever become — showbiz. Likewise, the marks of success in ministry are neither wealth nor fame but *faithfulness*. If televangelists wish to

operate like rock stars then they need to at least be honest about their enterprises and the purpose behind them. They should sell tickets instead of soliciting contributions. If they wish to operate on a for-profit basis, they should be taxed as a business and not as a "church," and the contributions they receive ought not to be tax deductible. The followers should understand that they are attending not a service of worship, but an entertaining show which includes a presentation by a motivational speaker.

CHAPTER 18
Culture Wars

The campaign and rally slogan, "Make America Great Again," employed by President Donald Trump implies that there was once a time in the past when America was great. It also implies that America is no longer great. However, this "great" time period has never been specified. For some, America might have last been great in 1950; perhaps for others it was 1850. For our purposes, let's assume the phrase refers to American culture as it was during the 1950s.

The culture wars that are tearing at the fabric of American society are a yearning to return to simpler, safer, more comfortable times; it is also a rejection of modernity and all of the staggering social changes that have occurred over the past 70 years.

Today, there is a backlash against changes in sexual morality, such as the availability of birth control, increasing rates of cohabitation, the prevalence of premarital sex, LGBTQ people living in the open, and the general acceptance of divorce. There is a backlash against the growing diversity of our nation. Some people feel that they have lost their country when they find that Spanish has become the primary language at their grocery store. There

is a sense of loss over the waning of the Church as the focus of society and the source of moral guidance. As the Church faces decline, the religious right faces a growing panic that it has lost control over the national agenda. The current backlash over abortion is one sign of a desperate attempt to reassert that control.

The safety and security America experienced during the 1950s was a very Norman Rockwell concept. While America certainly prospered and "family ideals" thrived, the safety and security of that age was actually rather marginally experienced specifically by the white male establishment. To be a "real American" in the 1950s, one needed to be a WASP (White Anglo-Saxon Protestant). In 1960, people were shocked to see an Irish Catholic run for president and were even more shocked when he won.

Imagine the well-ingrained image of the pristine 1950s life as portrayed by Norman Rockwell depictions and family shows on television. The white picket fence, green lawn, and cozy home filled with well-dressed children and a beautiful, healthy wife who cooked dinner for you after you returned from your comfortable job. But that idealized image was far from the case for many.

The following list more accurately describes the social fabric of the 1950s for the majority:

- All power and authority were held firmly by the white, male elite.

- The (white) man was the breadwinner and head of the household.

- Racial segregation was the law of the land. Colored people "knew their place" and were expected to be submissive. It was a time of "whites only" drinking fountains and staunch racism throughout the country.

- Hispanics were not yet a major component of our demographic makeup.

- Women had few good options for birth control. Most women were homemakers; there were only a few jobs available for

women in the workforce, such as teacher, nurse, secretary, waitress, or retail workers.

- Decent people did not divorce. Any divorce was seen as a scandal.

- Unmarried couples could be arrested for cohabitation or even sharing a hotel room.

- Gay men were met with contempt, bullying, arrest, and even chemical castration.

- The Church was the unquestioned moral authority.

- Church attendance was common.

Society has evolved and improved a lot since the 1950s. Some, especially white males raised in this decade, saw this period as one of stability and prosperity under the Eisenhower administration. However, when we examine the social climate of that time, there were a lot of shocking injustices. The 1950s were not great for people of color, women, or for the LGBTQ community.

If I may introduce a British example, consider the case of Alan Turing, who played a pivotal role in defeating the Germans during World War II. He was able to break the German Enigma code, allowing the Allies to receive and decode German military commands on a timely basis, sometimes even before these commands were received by the German field commanders. In order to break this code, Turing had to invent the Turing machine, which is considered to be the first modern, general-purpose computer.

In 1952, Alan Turing was arrested for "gross indecency" — meaning homosexual acts. He chose chemical castration to avoid prison. He died two years later of apparent suicide.

While the 1950s were seen by some as a golden age of comfort and prosperity, this was certainly not true for everyone. It was a golden age only for straight WASP males.

CHAPTER 19
Religion and Politics

Jesus and the prophets gave meaning to the concept of real ministry. In the following passage from Luke 4, Jesus is quoting from the Book of Isaiah:

> The Spirit of the Lord is upon me, because He has anointed me to preach good news to the poor. He has sent me to proclaim release to the captives and recovery of sight to the blind, to set at liberty those who are oppressed, to proclaim the acceptable year of the Lord. (Luke 4:18–19)

The work and rhetoric of the modern religious right seem utterly disconnected from real, prophetic ministry as defined above. In recent years, there has been a hostile takeover of the American Church by the Republican Party; this has been a most unholy alliance. With this takeover, the ideals and messages of the American Church have also shifted sharply to the right. Driven by the cultural backlash as described in the last chapter, the Church has retreated from the social progress made over the past 70 years.

The Church, captured by Republicans, now seems devoid of Christian values. I am reluctant to identify myself as a Christian in this sad hour. If and when I do identify myself as a Christian, I am quick to point out that I do not hate gay people; I do not think that single mothers are sluts; I do not believe that non-Christians will burn in hell; I do not believe in creationism, or that the world was created in 4004 BCE; I do not believe in white supremacy, or Christian supremacy for that matter.

The Church of Republican captivity believes that discrimination against the LGBTQ community is justified. Former congresswoman Michele Bachmann proclaimed Donald Trump to be highly biblical when he booted transgender troops out of the military.

> [Trump] is highly biblical, and I would say to your listeners, we will in all likelihood never see a more godly, biblical president again in our lifetime. So we need to be not only praying for him, we need to support him, in my opinion, in every possible way that we can.[67]

The Alabama abortion laws passed in 2019 are the most restrictive in the country.[68] Under these laws, abortion is allowed *only* when the mother's life is at risk or when the fetus is non-viable — there is no exception for rape or incest. Abortion is now a felony homicide. Any woman who has a miscarriage is at risk and might need to prove somehow that she had a miscarriage and not a self-induced abortion.

Also enacted in 2019 were the so-called "heartbeat" laws of several states including Missouri, Mississippi, Louisiana, and Georgia, which prohibit abortion as soon as the fetus's "heartbeat" can be heard on a sonogram.[69] This effectively narrows the window for legal abortions to the first few weeks of pregnancy, when it is unlikely the woman even knows that she is pregnant. What's more, many doctors contend that the "heartbeat" that is described in the law is not a true heartbeat at all, but simply a muscle twitch in tissues that will eventually become a heart.[70]

The Church of Republican captivity has come to stand for ignorance, bigotry, hatred, and cruelty. It opposes science. It demeans women, denying

them even control over their own bodies. It treats poverty as a crime. It takes away what little the poor have to increase the coffers of the super rich. It causes a growing chasm between the "haves" and the "have nots." It believes that healthcare is a privilege that should be granted only to those who can afford it. But it believes the right to own dangerous weaponry should extend to every person, even those on no-fly lists or with histories of mental illnesses.

As Michele Bachmann has made evident, the Church of Republican captivity idolizes the most criminal, most corrupt, most morally depraved, and most dangerous president in American history. The great American experiment in self-government is in jeopardy. Our democracy is under siege, and is on the way to being replaced by a fascist kleptocracy.

The church of Republican captivity has become unfit for Christians. It has become oppressive, destructive, and demented. If we are not diligent, we will lose both our democracy and our Church in a very short space of time. The captive American Church resembles the German Church in the 1930s.

CONCLUSION
Spirituality for a Secular Age

As I have expressed often throughout this book, you must choose a faith journey that is appropriate and comforting to you — no one can make that decision for you. I can only lift the curtain in order to help you make an informed choice, and I hope I have done that.

The focus of this book has been on participation in organized religion. But before concluding, I wanted to acknowledge that there is more to spirituality than organized religion. Spirituality may or may not include participation in religious observances; many spiritual people live lives of quiet, personal spiritual connection to a deity or the universe at large without ever entering a church, synagogue, temple, or mosque. Some of my most spiritual moments have been on mountain tops or walking through redwood forests that feel like living cathedrals. I love to gaze up into the heavens and experience the intimacy of knowing each star and planet by name.

Throughout all of human history and prehistory, humans have known some form of religion. Religion is so prevalent that it must be somehow hardwired into our DNA. Even Neanderthals buried their dead.

There have been several evolutionary advantages conferred by religious observance throughout the ages. The first seems to be delayed gratification, which allowed people to forego immediate consumption in order to prepare for the future. Tasks that yielded no immediate benefit like tool-making, planning, and education took the place of baser, more immediately gratifying focuses. This shift allowed for humans to improve future prospects. Delayed gratification means saving back seed corn for planting next year instead of consuming it all in the present; it means planting trees that will not bear fruit for years; it means making alliances instead of warring with competing clans.

This nourishing development and growth of tribes and communities is another evolutionary advantage. Tribes flourish when there is cooperation as opposed to competition among members.

I will admit that there are things I miss about attending church. I miss the sense of community that participation in a worshipping congregation offers. As noted earlier, a community of faith is like an extended family. Like all families, congregations will have their dysfunctional elements. There may be people there that you do not like, some you find aggravating, and others who are just plain weird. Being a part of a community means embracing the whole community and working for its harmony and welfare rather than just for your own.

I miss the weekly routine of worship. Worship can bring beauty, ritual, and tranquility to an otherwise dull life. It focuses our minds and raises our best voices and energies. It creates a sense of participation. It turns our minds to justice and compassion. It brings transcendence and lifts us to a higher spiritual plane. For a moment, we are freed from our daily toils and troubles.

But there are also downsides to religious participation that keep me away. Church finances are an easy starting place. While every church is different, based on my experience I believe that the following is a reasonable assumption of financial impact for a church of 100 members. Of the $1,162 contribution from each member to the neighborhood church, 98 percent

of this will be absorbed by the church to pay for its staffing, occupancy, and supply expenses. This leaves $23 for all mission beyond the local church. If you have a particular cause that you want to support, such as feeding the hungry, perhaps $2 of the $23 will go towards feeding the hungry. Perhaps direct contribution to those causes would be better served.

Churches are strapped for money and volunteers. It is too easy for neighborhood churches to go into survival mode. When this happens, the church becomes fearful and self-absorbed, and loses any sense of mission. Often, the church then becomes obsessed with bringing in new members. This is a losing battle as church participation is no longer the norm in society. The church's evangelism efforts are about as welcome as telemarketers and for the same reason. Unable to grow, the neighborhood church falls into a downward spiral.

Being part of a worshipping community means inevitably dealing with some portion of the congregation who possess totally outmoded beliefs and values. The result is often a continuing rear-guard battle against fundamentalism, one which is as unproductive as it is aggravating.

A pastor is "required" to polish the illusion that God is our ever-present nanny, guardian angel, or fairy godmother. *God can fix anything, and will do whatever He can for our safety, comfort, convenience, and support.* This involves anything from curing a sick gallbladder to turning away a hurricane. I can imagine a different sort of church where the participants are made stronger and more resilient as opposed to being coddled.

The Bible is sometimes interpreted as God speaking directly to us through words on a page. Many see it as the road map to a righteous life and salvation. Some take it as a secret code book. Still others look at it as a book with magic powers. In truth, it is no more than a collection of campfire stories about our relationship to God, compiled by Judeo-Christian communities of the past.

I believe that the Bible should be read in the same manner as we read Greek and Roman mythology, interpreting what is within as entertain-

ing stories that give us some insight into human nature and our universal predicament.

The Book of Joshua is the story of the genocidal conquest of Canaan by the Hebrews made possible by God's enthusiastic support and intervention. The conquest of Palestine by Israel following World War II was wrongfully given theological support and justification from this ancient text. The persecution of the Palestinians continues to this day under this false doctrine. The Palestinians are treated as stateless refugees in their own homeland. Benjamin Netanyahu and his government are actively trying to fill designated Palestinian lands with Jewish settlements in order to make any future two-state solution impossible.[71]

For me, the worst part of modern church participation comes from the national political situation lending inappropriate context to worship and religious living. The evangelicals sold their souls for political power; there is now an unholy alliance of evangelical Christianity with Republican politics. The takeover of the American Church by the Republican Party can only be compared to the takeover of the German church by the Nazis in the 1930s.

The craziest of the voices are now driving the bus — names include Franklin Graham, Pat Robertson, Jerry Falwell, Jr., Mike Pence, Mike Huckabee, Betsy DeVos, and more.

Franklin Graham attacked Pete Buttigieg for being publicly gay.[72] At one point, Graham said that Buttigieg deserved death. However, the evangelicals are losing the culture wars. Around 68 percent of Americans said that they would be comfortable with a gay candidate, while only 54 percent said that they would be comfortable with an evangelical candidate.[73]

It is ironic that Graham attacks Buttigieg's morality for living as openly homosexual yet sings the praises of Donald Trump despite his utter moral depravity. What's more, the president's depravity extends even beyond the sexual issues of adultery and prostitution. It also includes racism, criminality, cruelty, and lying (with 10,000 public lies recorded so far in his

administration[74]). With such warped values, the evangelicals are lending inaccurate characterizations to the Church and, as a result, effectively killing it off. The Church as described by the religious right it is not a fit place for true Christians.

There is both a cost and a benefit to participating in organized religion. To participate or not is a choice that we all must make based on our own needs, aspirations, and circumstances; we in America have a legally protected right to make this choice. When we do choose to participate, we must be wary of falling into fanaticism or zealotry. We must not use our faith journey to abuse or discriminate against others. Other people, regardless of their beliefs, are entitled to their full humanity, which includes the freedom to make their own religious choices.

To me, a former pastor, the cost of participation in organized religion has grown too high. Ancient campfire stories serve us poorly in the 21st century. We can either continue the endless rear-guard battle against bigotry, superstition, and ignorance, or we can move forward.

The choice is given to each one of us.

Bibliography

1. "Neanderthal Burials Confirmed as Ancient Ritual." National Geographic. National Geographic Society, October 4, 2017. https://news.nationalgeographic.com/news/2013/12/131216-la-chapelle-neanderthal-burials-graves/.

2. Mark, Joshua J. "Burial." Ancient History Encyclopedia. Ancient History Encyclopedia, August 14, 2019. https://www.ancient.eu/burial/.

3. Wing, Nick. "In A Congress Full Of Firsts, Still No Open Atheists." HuffPost. HuffPost, January 7, 2019. https://www.huffpost.com/entry/congress-atheists-representation_n_5c2f9b03e4b0bdd0de588425.

4. Dcoxpolls. "Way More Americans May Be Atheists Than We Thought." FiveThirtyEight. FiveThirtyEight, May 18, 2017. https://fivethirtyeight.com/features/way-more-americans-may-be-atheists-than-we-thought/.

5. "The God Delusion." The Guardian. Guardian News and Media, September 23, 2006. https://www.theguardian.com/books/2006/sep/23/richarddawkins.

6. Krauss, Lawrence M. *A Universe from Nothing: Why There Is Something Rather Than Nothing*. New York, NY: New York Free Press, 2012.

7. Greene, Nick. "Meet the Father of the Big Bang Theory." ThoughtCo. ThoughtCo, July 3, 2019. https://www.thoughtco.com/georges-lemaitre-3071074.

8. Henig, Robin Marantz. *The Monk in the Garden: the Lost and Found Genius of Gregor Mendel, the Father of Genetics*. Boston, MA: Houghton Mifflin, 2001.

9. "The Galileo Project: Biography: Inquisition." The Galileo Project | Biography | Inquisition. http://galileo.rice.edu/bio/narrative_7.html.

10. Robert-Fleury, Joseph-Nicolas. "Vatican Admits Galileo Was Right." New Scientist, November 7, 1992. https://www.newscientist.com/article/mg13618460-600-vatican-admits-galileo-was-right/.

11. "Joplin Tornado." 2011 Joplin Tornado Facts and Information | TornadoFacts.net. Lylesoft LLC. https://www.tornadofacts.net/tornado-records/joplin-tornado.html.

12. "St. Mary Parish, Joplin, MO, Founded 1938." DioSCG, March 22, 2019. http://dioscg.org/index.php/about/diocesan-history/st-mary-parish-joplin-mo/.

13. David Hume. *Dialogues Concerning Natural Religion*. Hardpress Ltd., 2013.

14. Richter, Viviane. "The Big Five Mass Extinctions." Cosmos, July 6, 2015. https://cosmosmagazine.com/palaeontology/big-five-extinctions.

15. "Anthropocene." Anthropocene, March 20, 2018. https://theanthropocene.org/topics/extinction/.

16. Arnett, David. *Supernovae and Nucleosynthesis: an Investigation of the History of Matter, from the Big Bang to the Present*. Princeton, NJ: Princeton Univ. Press, 1996.

17. "Yellowstone Supervolcano Revealed." Yellowstone Forever, May 9, 2019. https://www.yellowstone.org/yellowstone-supervolcano-revealed/

?gclid=CjwKCAjw8LTmBRBCEiwAbhh-6M8Bs_D1w37FDtwfKYd
kt3rdwHPKwsBg-O5K5IDlcgQtEAZv7ypahxoCmbEQAvD_BwE.

18. Choudhury, Samarpita. "Yellowstone Supervolcano Location, History, and Important Facts." ScienceStruck. ScienceStruck, March 20, 2019. https://sciencestruck.com/yellowstone-supervolcano-location-history-important-facts.

19. Hanks, B. "Understanding Plate Motions." This Dynamic Earth, USGS, September 15, 2014. https://pubs.usgs.gov/gip/dynamic/understanding.html.

20. Walker, Gabrielle. *Snowball Earth: the Story of the Great Global Catastrophe That Spawned Life as We Know It.* London: Bloomsbury, 2004.

21. "Cambrian explosion explained." 2019. https://everything.explained.today/Cambrian_explosion/.

22. Flynn, Rachel M. "It's Impossible To Forget These 10 Horrific Winter Storms That Have Gone Down In Iowa History." Only In Your State, November 27, 2017. https://www.onlyinyourstate.com/iowa/10-horrific-winter-storms-that-have-gone-down-in-ia-history/.

23. Gritters, Jenni W. "The Potential Devastating Effects of Coronal Mass Ejections." Northrop Grumman, May 29, 2018. https://now.northropgrumman.com/the-potential-devastating-effects-of-coronal-mass-ejections/.

24. Redd, Nola T. "Red Giant Stars: Facts, Definition & the Future of the Sun." Space.com. Space, March 28, 2018. https://www.space.com/22471-red-giant-stars.html.

25. Grad, Shelby, and David Colker. "Nancy Reagan Turned to Astrology in White House to Protect Her Husband." Los Angeles Times. Los Angeles Times, March 6, 2016. https://www.latimes.com/local/lanow/la-me-ln-nancy-reagan-astrology-20160306-story.html.

26. Carroll, Robert T. "Astrology." The Skeptic's Dictionary, October 20, 2015. http://skepdic.com/astrology.html.

27. Kelly, Ivan W. "Concepts of Modern Astrology: A Critique." Astrology and Science. 2005. http://www.astrology-and-science.com/a-conc2.htm.

28. Carroll, Robert T. "Astrology." The Skeptic's Dictionary, October 20, 2015. http://skepdic.com/astrology.html.

29. Cross, F. L., and Elizabeth A. Livingstone. *The Oxford Dictionary of the Christian Church*. Oxford: Oxford University Press, 2012.

30. "A Pale Blue Dot." The Planetary Society Blog. 2006. http://www.planetary.org/explore/space-topics/earth/pale-blue-dot.html.

31. Mellowes, Marilyn. "More About Q and the Gospel of Thomas." PBS. April 1998. https://www.pbs.org/wgbh/pages/frontline/shows/religion/story/qthomas.html.

32. Martin, Dale B. *New Testament History and Literature*. New Haven: Yale University Press, 2012.

33. Rendsburg, Gary. "The Biblical Flood Story in the Light of the Gilgamesh Flood Account." In *Gilgamesh and the World of Assyria*, by J. Azize and N. Weeks, 117. 2007.

34. Raj, Frank. "Gandhi Glimpsed Christ, Rejecting Christianity as a False Religion." The Washington Times. December 31, 2014. https://www.washingtontimes.com/news/2014/dec/31/gandhi-glimpsed-christ-rejecting-christianity-fals/.

35. Hillerbrand, Hans J. *The Protestant Reformation*. Harper Collins Publishers, 1998.

36. Rojas, Rick, Liam Stack, Jacey Fortin, et al. "Roman Catholic Church Sex Abuse Cases." The New York Times. https://www.nytimes.com/topic/organization/roman-catholic-church-sex-abuse-cases.

37. Pullella, Philip. "Vatican Stunned by Irish Embassy Closure." Reuters. November 04, 2011. https://www.reuters.com/article/us-vatican-ireland/vatican-stunned-by-irish-embassy-closure-idUSTRE7A33D120111104?feedType=RSS&feedName=worldNews.

38. Metaxas, Eric. *Bonhoeffer: Pastor, Martyr, Prophet, Spy.* Nashville: Thomas Nelson, 2015.

39. Gumbel, Andrew. "Junípero Serra's Brutal Story in Spotlight as Pope Prepares for Canonisation." The Guardian. September 23, 2015. https://www.theguardian.com/world/2015/sep/23/pope-francis-junipero-serra-sainthood-washington-california.

40. Drury, Amanda. "How Prayer Works." The Institute for Youth Ministry. March 03, 2017. http://iym.ptsem.edu/how-prayer-works/.

41. Cassedy, James H. *Highlights in the Development of Medical History in the United States: Materials from an Exhibit.* Bethesda, MD: U.S. Dept. of Health and Human Services, Public Health Service, National Institutes of Health, 1984.

42. Gandhi, Lakshmi. "A History Of 'Snake Oil Salesmen'." NPR. August 26, 2013. https://www.npr.org/sections/codeswitch/2013/08/26/215761377/a-history-of-snake-oil-salesmen.

43. Hunt, Katie. "Chinese Medicine Gains WHO Acceptance but It Has Many Critics." CNN. May 26, 2019. https://www.cnn.com/2019/05/24/health/traditional-chinese-medicine-who-controversy-intl/index.html.

44. "Poaching: Rhino Threats: Save the Rhino International." Save The Rhino. Accessed August 16, 2019. https://www.savetherhino.org/rhino-info/threats/poaching-rhino-horn/.

45. Ghose, Tia. "Will Fake Rhino Horns Curb Poaching?" LiveScience. June 26, 2015. https://www.livescience.com/51354-synthetic-rhino-horn-decrease-poaching.html.

46. "A Quote from Letters of Thomas Jefferson." Goodreads. Accessed August 16, 2019. https://www.goodreads.com/quotes/110347-and-the-day-will-come-when-the-mystical-generation-of.

47. Associated Press. "Kentucky Clerk Jailed over Gay Marriage Licenses Loses Re-election Bid." NBCNews.com. November 07, 2018. https://

www.nbcnews.com/feature/nbc-out/kentucky-clerk-jailed-over-gay-marriage-licenses-loses-re-election-n933451.

48. Swoyer, Alex. "Supreme Court Sides with Christian Baker in Same-sex Wedding Cake Case." The Washington Times. June 04, 2018. https://www.washingtontimes.com/news/2018/jun/4/scotus-sides-baker-same-sex-wedding-cake-case/

49. Elwell, Walter A. "Spirit Definition and Meaning — Bible Dictionary." Bible Study Tools. 1996. https://www.biblestudytools.com/dictionary/spirit/.

50. "7 Startling Facts: An Up Close Look at Church Attendance in America." Church Leaders. July 19, 2019. https://churchleaders.com/pastors/pastor-articles/139575-7-startling-facts-an-up-close-look-at-church-attendance-in-america.html.

51. Duffin, Erin. "Church Attendance of Americans 2018." Statista. August 9, 2019. https://www.statista.com/statistics/245491/church-attendance-of-americans/.

52. "Summary of Statistics: Comparative Summaries 2017." PCUSA.org. 2017. https://www.pcusa.org/site_media/media/uploads/oga/pdf/statistics/2017_comparative_summaries.pdf.

53. Oberdorfer, Don. *Princeton University: The First 250 Years*. Vol. 25. The William G Bowen Series. Princeton (N.J.): Princeton University Press, 1995.

54. "Summary of Statistics: Comparative Summaries 2017." PCUSA.org. 2017. https://www.pcusa.org/site_media/media/uploads/oga/pdf/statistics/2017_comparative_summaries.pdf.

55. Ibid.

56. Ibid.

57. Popik, Barry. ""When Christianity Came to America, It Became a Business"." The Big Apple. March 25, 2014. https://www.barrypopik.com/index.php/new_york_city/entry/when_christianity_came_to_america_it_became_a_business/.

58. Nussbaum, Paul. "A Global Ministry of 'Muscular Christianity': 'Purpose Driven Life' Author Taking On Poverty, Disease." *Washington Post*, January 26, 2006.

59. Applebome, Peter. "Bakker Sentenced to 45 Years For Fraud in His TV Ministry." The New York Times. October 25, 1989. https://www.nytimes.com/1989/10/25/us/bakker-sentenced-to-45-years-for-fraud-in-his-tv-ministry.html.

60. Inside Edition Staff. "Investigation Shows Televangelists Living Lavish Lifestyles." Inside Edition. May 03, 2019. https://www.insideedition.com/investigation-shows-televangelists-living-lavish-lifestyles-52662.

61. Chasmar, Jessica. "Preacher Kenneth Copeland Defends Lavish Spending in Tense Interview: 'I'm a Very Wealthy Man'." The Washington Times. June 03, 2019. https://www.washingtontimes.com/news/2019/jun/3/kenneth-copeland-preacher-defends-lavish-spending-/.

62. An, Kirkland. "Even If Joel Osteen Did the Right Thing, He Lost a Chance to Teach Christianity." USA Today. September 02, 2017. https://www.usatoday.com/story/opinion/2017/09/02/joel-osteen-right-close-lakewood-church-but-he-lost-chance-teach-christianity-kirkland-an-column/622215001/.

63. Schmidt, Megan. "8 Richest Pastors in America." Beliefnet. January 25, 2018. https://www.beliefnet.com/faiths/christianity/8-richest-pastors-in-america.aspx?p=2.

64. Hinn, Costi W. *God, Greed, and the (Prosperity) Gospel: How Truth Overwhelms a Life Based on Lies*. Zondervan, 2019.

65. Osteen, Joel. *Next Level Thinking: 10 Powerful Thoughts for a Successful and Abundant Life*. New York: FaithWords, 2018.

66. Ellis, Blake. "5 Most Common Financial Scams." CNNMoney. September 12, 2013. https://money.cnn.com/2013/09/12/pf/financial-scams/index.html.

67. Cillizza, Chris. "Michele Bachmann Claimed That Donald Trump Is 'highly Biblical.' So ..." CNN. April 16, 2019. https://www.cnn.

com/2019/04/16/politics/michele-bachman-donald-trump-bible-religious/index.html.

68. Law, Tara. "Abortion Bill Details: Alabama, Georgia, Missouri Laws Explained." Time. May 18, 2019. https://time.com/5591166/state-abortion-laws-explained/.

69. Ibid.

70. Ibid.

71. Myre, Greg, and Larry Kaplow. "7 Things To Know About Israeli Settlements." NPR. December 29, 2016. https://www.npr.org/sections/parallels/2016/12/29/507377617/seven-things-to-know-about-israeli-settlements.

72. "Franklin Graham Challenges Pete Buttigieg, but Voters Unlikely to Care." Religion News Service. April 29, 2019. https://religionnews.com/2019/04/26/franklin-graham-challenges-pete-buttigieg-but-voters-unlikely-to-care/.

73. Ibid.

74. Allsop, Jon. "After 10,000 'false or Misleading Claims,' Are We Any Better at Calling out Trump's Lies?" Columbia Journalism Review. April 30, 2019. https://www.cjr.org/the_media_today/trump_fact-check_washington_post.php.

About the Author

Greg Bentall has a broad range of interests, including history, politics, and science. He believes that nothing can be understood apart from its historical development. Science is not a body of accepted findings but a historical journey to progressively comprehend the workings of nature. Religious thought must be understood by means of the same historical development process. He has blogged on the interface of science, politics, and religion.

Greg is a skeptic who questions everything, and seeks to embrace new ideas and constructs.

Greg has reinvented himself many times. At one point, he was working as a financial manager in a social service agency while volunteering his pastoral services to a small congregation in the Wine Country of Northern California. When he took a new job in the casino industry, he told the congregation that since most of them were in the winery business, he felt obligated to do something "respectable" by taking the casino job.

Now retired, Greg has time to pursue his love of writing and philosophy.

Read more from the author on his blog at www.gregbentall.com.

Made in the
USA
Monee, IL